DEALING
WITH DIFFICULT
SITUATIONS

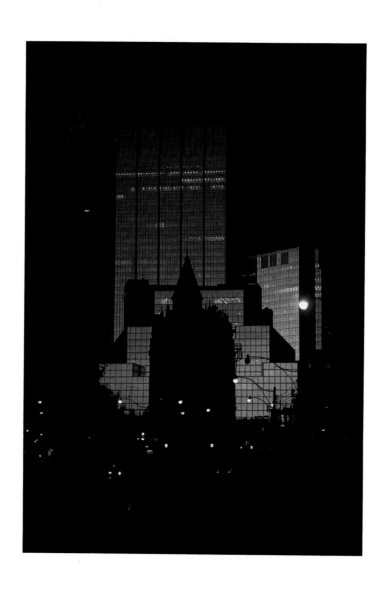

DEALING
WITH DIFFICULT
SITUATIONS

Published by Time-Life Books in association with Kodak

DEALING WITH DIFFICULT SITUATIONS

Created and designed by Mitchell Beazley International
in association with Kodak and TIME-LIFE BOOKS

Editor-in-Chief
Jack Tresidder

Series Editor
Robert Saxton

Art Editor
Mike Brown

Editors
John Farndon
Richard Platt
Carolyn Ryden

Designers
Ruth Prentice
Eljay Crompton

Picture Researchers
Veneta Bullen
Jackum Brown

Editorial Assistant
Margaret Little

Production
Peter Phillips
Androulla Pavlou

Consulting Photographer
Michael Freeman

Coordinating Editors for Kodak
Paul Mulroney
Ken Oberg
Jackie Salitan

Consulting Editor for Time-Life Books
Thomas Dickey

Published in the United States
and Canada by TIME-LIFE BOOKS

President
Reginald K. Brack Jr.

Editor
George Constable

The KODAK Library of Creative Photography
© Kodak Limited. All rights reserved

Dealing with Difficult Situations
© Kodak Limited, Mitchell Beazley Publishers,
Salvat Editores, S.A., 1985

Library of Congress catalog card number
ISBN 0-86706-246-0
LSB 73 20L 17
ISBN 0-86706-245-2 (Retail)

Contents

6 Meeting the Challenge

16 Special Conditions

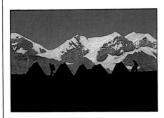

18 Deserts/1
20 Deserts/2
22 Ice and snow/1
24 Ice and snow/2
26 Rain and storm
28 Tropical rain forest/1
30 Tropical rain forest/2

32 Underwater photography/1
34 Underwater photography/2
36 Underwater photography/3
38 Underwater photography/4
40 The camera aloft/1
42 The camera aloft/2
44 Mountain photography

46 Photography
 underground/1
48 Photography
 underground/2
50 Sailing photography/1
52 Sailing photography/2

54 The Expert Eye

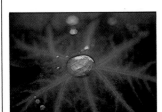

56 Being prepared
58 Using long telephoto lenses
60 Closing in/1
62 Closing in/2
64 Closing in/3
66 The night sky/1
68 The night sky/2

70 The stage performance/1
72 The stage performance/2
74 The stage performance/3
76 The calculated illusion/1
78 The calculated illusion/2
80 The calculated illusion/3
82 The remote-control camera/1

84 The remote-control
 camera/2
86 Photography in
 museums

88 The Special Assignment

90 Food on location
92 Olympic skiing
94 Insects in flight
96 Hotel in the Tropics
98 Volcanoes
100 Jets in flight

102 Glossary 103 Index 104 Acknowledgments

MEETING THE CHALLENGE

Although today's sophisticated cameras can make photography easier than ever before, there is no shortage of photographic challenges that will tax your abilities to the limit. Some photographers thrive on such challenges, trying against the odds to obtain remarkable images like that of the volcano opposite. Photographs like these startle the viewer and provoke a string of admiring questions: How did the photographer protect himself and his equipment from the elements? How did he get the right viewpoint? How did he judge exposure satisfactorily in problematic lighting conditions?

The images on the following nine pages are as far removed as possible from the casual snapshot. Each picture demanded thorough preparation and improvisational skill, as well as a determination to succeed. Some of the photographs also required special equipment, photographic or other, and specialized camera techniques.

The joy of conquering difficult situations to achieve dramatic or beautiful images, whether close to home or in remote locations, is an experience readily available to any photographer. The degree of difficulty involved is entirely your own choice. If you believe from the start that a problem is surmountable, you will be surprised how often you find a convenient solution.

A volcano in Indonesia throws fiery streaks into the night. The long exposure required for this image would not have been feasible from the safety of an airplane. The photographer therefore hiked up a neighboring peak to set up a tripod-mounted camera.

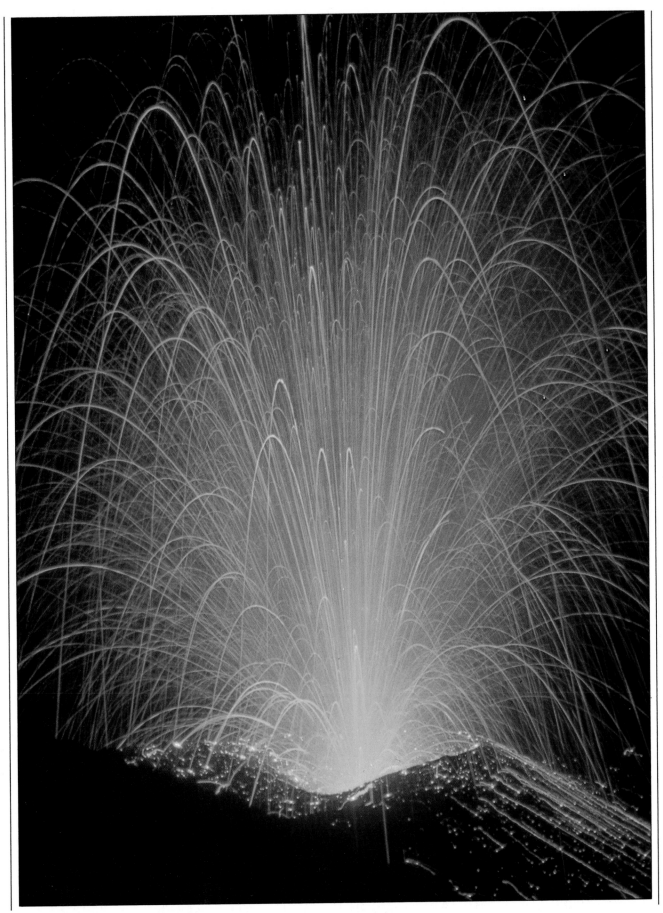

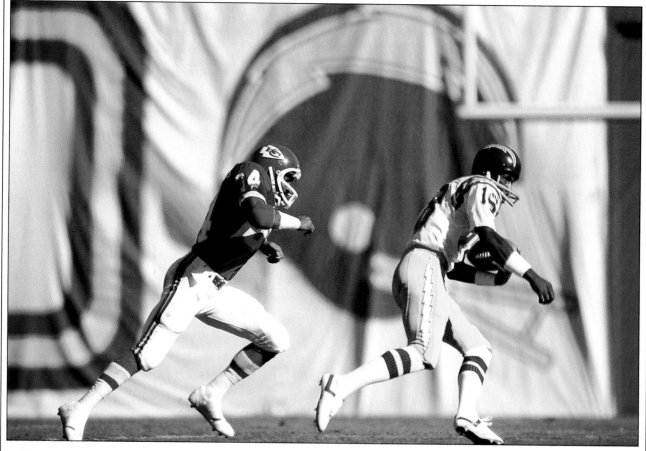

A football player moves in for a
tackle in a view taken from the edge of
the field with a 600mm lens mounted on a
monopod. The photographer isolated one
player within his viewfinder and followed
him around the field, continually
refocusing as necessary until this
dramatic moment occurred.

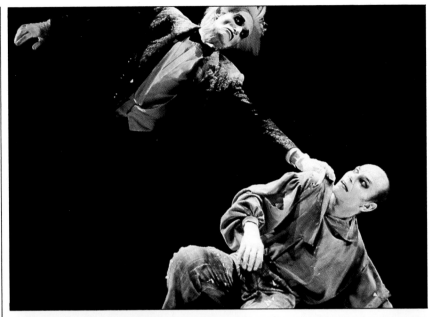

Mimers (left) enact a violent quarrel scene on stage. To fill the frame with the action, the photographer closed in with a 105mm lens from a seat in the 10th row of the theater. A spot meter gave an accurate indication of exposure.

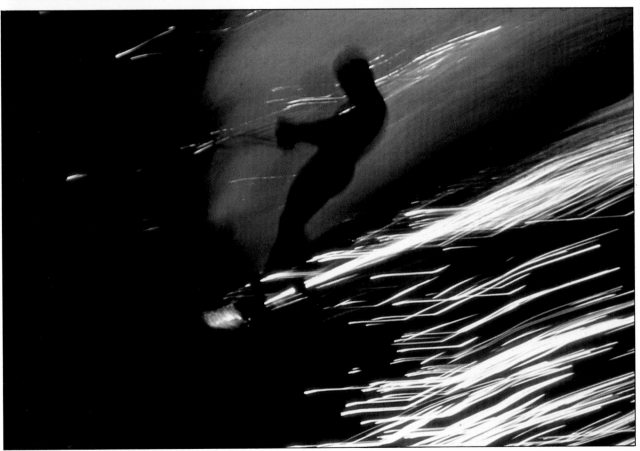

A silhouetted waterskier forms the focus of a semi-abstract image, taken with a 200mm lens. Because he needed to seize the moment before it passed, the photographer had to rely on his own judgment for the exposure setting. To elongate the reflected highlights, he panned the camera steadily.

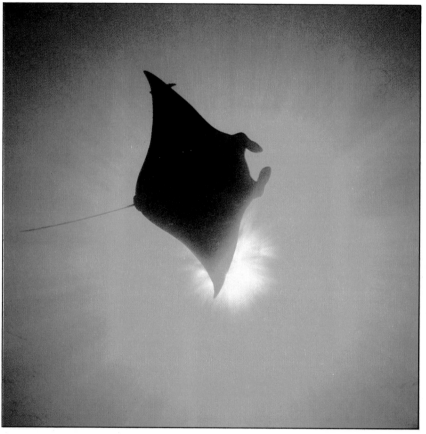

A manta ray eclipses the sun in an underwater photograph taken looking up toward the ocean surface. Using available light only, the diver took the picture with a Nikonos underwater camera. Given the problems of getting into position and using the camera viewfinder satisfactorily, the image is extraordinarily well composed.

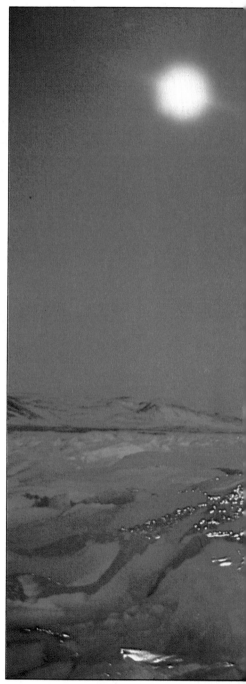

A view of a moonlit iceberg, wedged in a frozen sea off Greenland, was the reward of patient planning: the photographer had the image in mind for weeks before a full moon made it possible. To obtain the view that he wanted, he walked a mile over the ice. An exposure of 20 seconds at f/2.8 produced the best frame in a bracketed sequence.

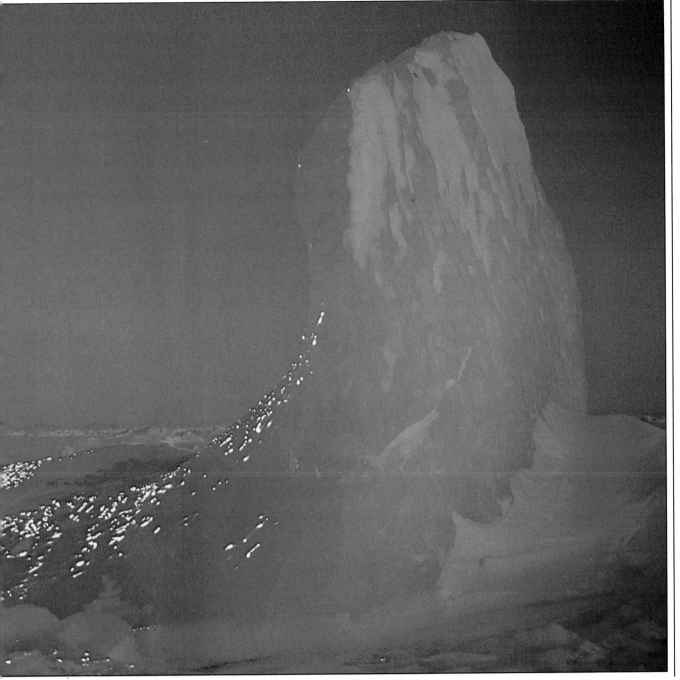

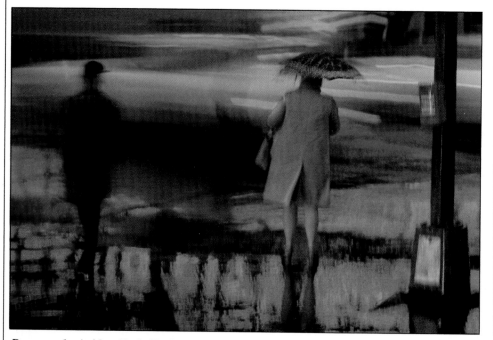

Passers-by in New York City brave
a heavy rainstorm. Anticipating the
dramatic color effects that would result
from reflections of car taillights in
the wet streets, the photographer
improvised a rainhood for his
camera, using a plastic bag with a hole
for the lens, and exposed several rolls of
film before the rain abated.

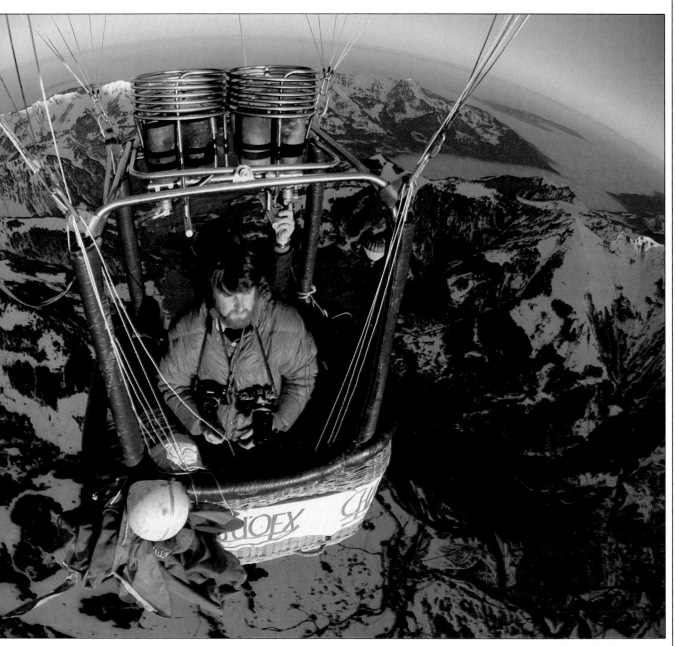

In the basket of a hot-air balloon, photographer Jerry Young poses for a self-portrait taken by a remote-controlled camera suspended from the balloon's frame. An extreme wide-angle lens bowed the Swiss Alps into a spectacular "globe"; but, because he is in the exact center of the frame, Young himself remains undistorted.

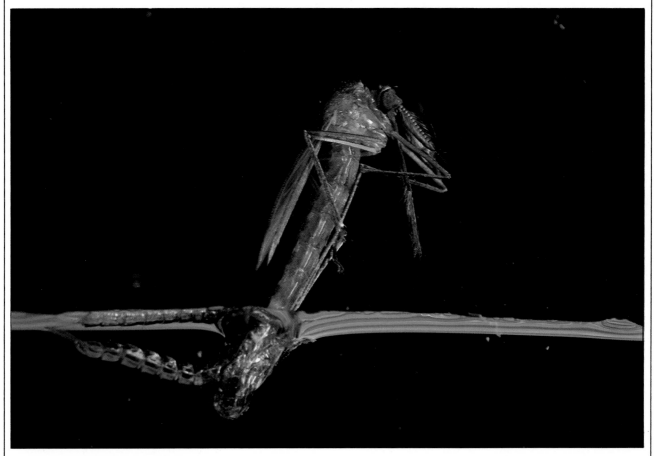

A mosquito clambers out of water in a studio close-up taken with a bellows extension. The insect was placed in a specially built glass tank, with a black backcloth positioned behind it and with light provided from one side. A black cardboard mask around the lens reduced reflections off the wall of the tank.

An underwater close-up reveals the beauty of marine flora in the waters of the Antarctic. A special flash unit attached to an underwater camera brought out the rich colors of the scene. Because optical rangefinders are unreliable for underwater close-ups, the diver used a rectangular wire frame projecting in front of the camera as a means of judging the subject distance.

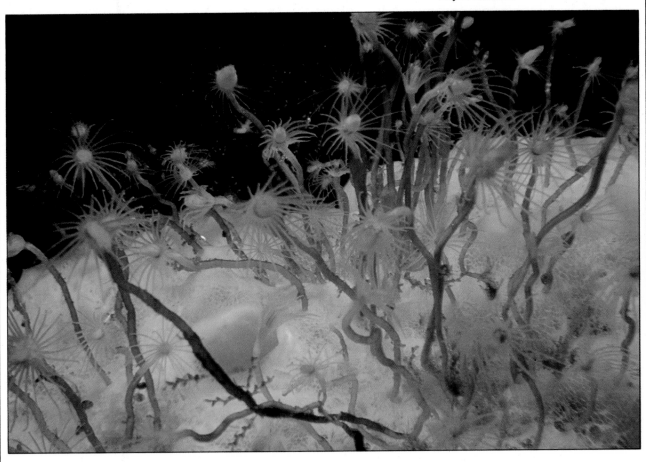

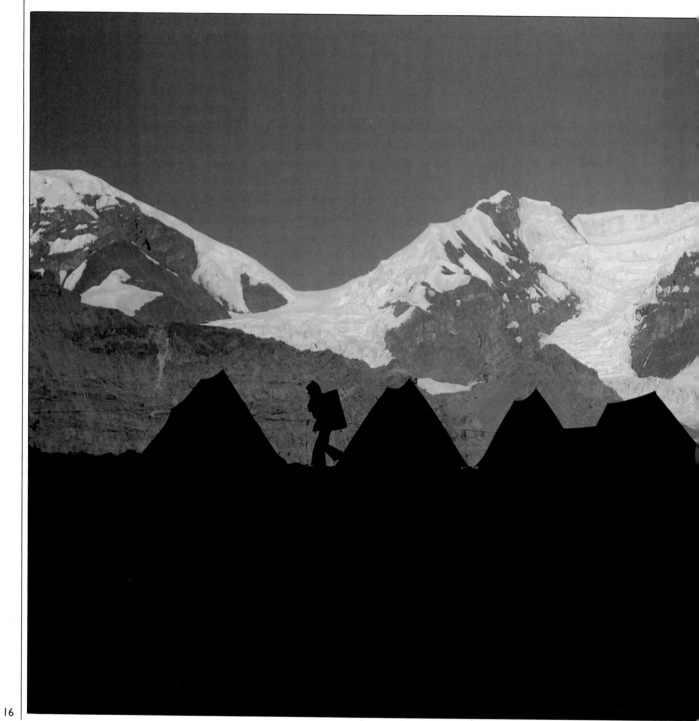

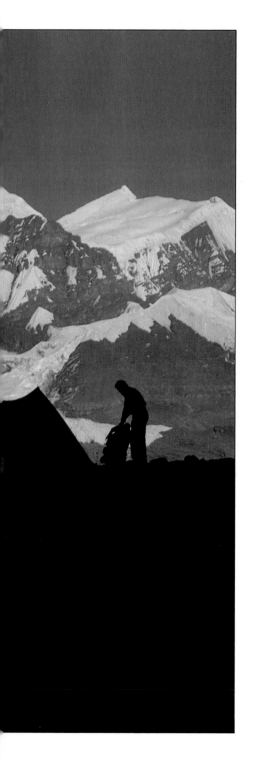

SPECIAL CONDITIONS

Photographers at every level may have to cope with extremes of setting. Certainly, penetrating the wilderness for pictures like the one at left requires stamina and self-reliance, and to these qualities a photographer must add specialized technical skills. To cope with desert heat, tropical humidity or polar cold, he must protect his equipment and film as well as his own comfort and safety.

Even taking photographs at a more humble level, such as in a rainstorm or from a light aircraft, may call for techniques beyond the standard repertoire.

The success of any photographer on expedition depends largely on being adequately prepared for the worst that the climate and physical conditions can bring. Modern cameras and films are not designed to withstand extreme situations, but there are various ways of squeezing an optimal performance from them, sometimes with the simplest of accessories. However, for some special activities, such as underwater photography, you may need to buy or rent special equipment.

Sometimes the problems of arduous conditions are compounded by difficulties of lighting and viewpoint. When the subject is elusive as well, you may be stretched to the very limit of your knowledge and resources. Overcoming such multiple challenges to create memorable pictures against all the odds is one of the most rewarding experiences any photographer can have.

Mountaineers and their tents make a graphic silhouette against a mountain range in Nepal. Bitterly cold nights at high altitudes make it essential to keep cameras and film warm, otherwise batteries and mechanical functions may fail, and film may become brittle and snap when you wind on.

Deserts/1

Photographers who want to capture on film the stark grandeur of desert scenery must prepare themselves and their equipment for encountering intense heat and penetrating dust or sand. The illustrations below show some of the defenses that you can employ against the worst conditions.

High temperatures speed a film's aging, making it less sensitive to light or, if the film is exposed, causing deterioration of image quality. Color films used in hot conditions may also show a color shift. Batteries may leak.

To avoid such problems, film and equipment must be kept cool. Take with you only the film you are likely to use, and pack it in a well-insulated box, such

as the type used on picnics. Or, as a handy expedient, you can store film in a suitcase among insulating layers of clothing. Never keep films or a camera in the glove compartment or on the back shelf of a car: under a baking sun, temperatures there can reach 135°F (57°C), which is close to the melting point of optical cements.

Whenever possible, take your pictures early or late in the day. This approach has two advantages: cooler conditions that are kinder to film, and longer shadows that can help define the contours of the landscape, as in the picture at right.

Wind and rewind film slowly to avoid static that can cause flash marks on the image. Avoid motor-

Combating desert conditions
Never carry more equipment than you need: in a cool hotel room you might not notice extra weight that could cause problems in the heat outside. When removing film from cold storage, allow sufficient warm-up time. Use white or shiny metal cases for carrying equipment. If your cases are black, keep them in the shade whenever possible or cover them with a white cloth.

Dark glasses are essential, but avoid the polarizing type when using a polarizing filter, or you will have problems adjusting the rotation correctly.

If you wear a wide-brimmed hat, be careful that the brim does not intrude into wide-angle views.

Take the precaution of covering the camera body and lenses with reflective white tape. A black camera or lens may become too hot to handle, causing you to drop it.

Keep a skylight or UV filter over the lens as an added precaution against dust or sand.

An insulated picnic box (above) is a good way to keep film cool; to protect film against moisture in a picnic box, place it in a sealed plastic bag. You can also carry refreshments in the same box.

Pay attention to your own comfort, so that you can concentrate more easily on photography. Wear white or pale-colored clothes that are loose, lightweight and made of natural fibers.

drives in dry heat. Process films as soon as possible.

Dust and sand can enter the tiniest gaps in a camera. Using the camera aggravates the problem, driving the grains further inside where they can scratch optical surfaces or jam delicate parts. To avoid such damage, clean the outside of your camera and lenses after every session with a blower brush and, if necessary, clean the inside in the same way between film changes. For a picture like the one below, take every precaution for keeping the camera as sheltered as possible right up to the moment of exposure. Never attempt to use a camera if you can hear grating sounds when you work the controls.

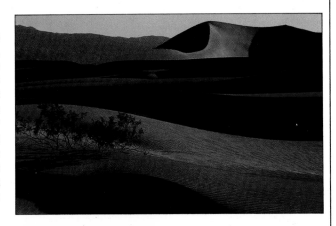

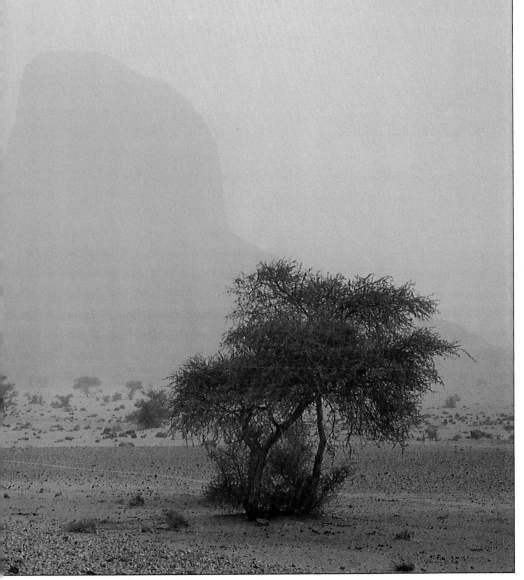

Dark shadows undulate across the dunes of California's Death Valley. The view was taken in the early evening, when the intense heat had abated and long shadows defined the shapes of the dunes.

A mountain of rock looms out of an orange dust cloud in Algeria. The photographer took the picture from the shelter of a Land Rover. To minimize the possibility of dust damage, he replaced the lens cap and put the camera back in his equipment case immediately after taking the picture.

Deserts/2

Desert conditions can make it difficult to create effective compositions. One common problem is haze, caused by dust or sand particles in the atmosphere. Although moderate haze can give an impression of depth, as in the picture below, the loss of distant detail and the blue cast created by atmospheric haze are normally undesirable. Telephoto lenses exaggerate these problems. A polarizing filter reduces haze most efficiently when used at an angle of 90° to the sun. Alternatively, use a skylight, 81A or UV filter; but remember that none of these filters will penetrate *visible* haze. You can best reduce

haze by choosing a camera position directly between the sun and the subject. However, this approach may produce a flat-looking image; to avoid the problem, compromise by choosing a viewpoint that offers some degree of sidelighting.

Another problem in deserts is heat shimmer. A higher viewpoint may help, or, alternatively, take your photographs at a cooler time of day. The light may fail before the shimmer abates; so early morning may be preferable to evening.

Haze reduces contrast, but on a clear day, when the sun is high and bright, or with medium or close-

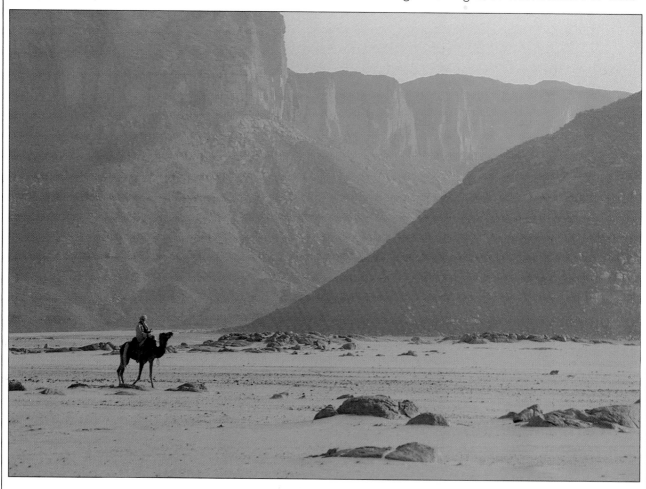

A Tuareg tribesman rides his camel through the Sahara, conveying scale in a view of towering rock faces. A UV filter helped to penetrate haze, but without detracting from the atmosphere and from the sense of distance.

up views, the opposite problem may occur: high contrast. For a scene such as the one below at right, follow an incident light or gray card reading, and bracket. Fill-in flash or reflectors can be useful for increasing shadow detail.

In the desert, distances can be longer than they seem. To increase your picture opportunities without having to travel far under a blazing sun in search of fresh viewpoints, carry a wide range of lenses. A wide-angle lens with a focal length of 28 mm or less is useful for making the most of nearby features, as in the larger picture below.

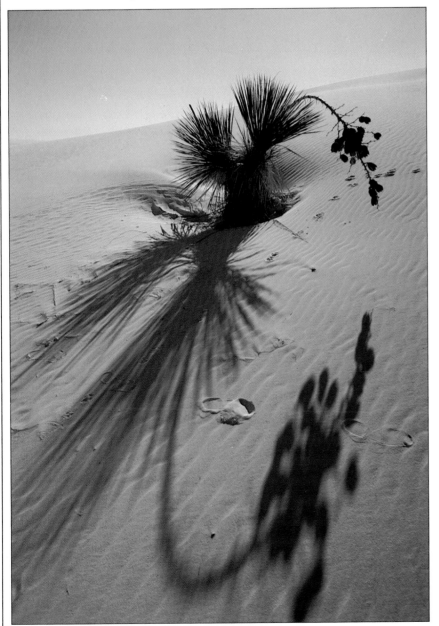

An expanse of rippled sand (above) contrasts with the smoother-looking surface on the other side of the dune in a wide-angle view. Exposing to preserve detail in the shadow side of the ridge bleached out the sunlit side.

A yucca plant (left) and its giant shadow dominate the frame in a view taken with a 28 mm lens. Although the sun was high in the sky, the steep slope of the dune lengthened the plant's shadow.

Ice and snow/I

The bitter cold of icy regions, or even of severe winters at home, can present a photographer with conditions as arduous as any he is likely to face. Extreme cold not only makes handling equipment physically difficult, it can also ruin film or prevent the camera from working altogether.

Most equipment works normally down to about 20°F (–7°C). Below this temperature, however, batteries begin to lose their power, with the result that parts dependent on batteries, such as electronic shutters and light meters, often slow down. One solution is to dispense with battery power altogether by using a camera with a mechanically operated shutter and a handheld selenium-cell light meter. Alternatively, make sure that batteries are kept as warm as possible. Keep the camera tucked inside your clothes whenever you are not taking pictures and carry a spare set of batteries in a warm pocket. Better still, use a pocket battery pack connected to the camera by a silicone rubber cable, as illustrated below.

In extreme cold, even mechanical functions may be affected, as lubricants thicken. Photographers used to have their cameras "winterized" by replacing all lubricants with thin oil. But the silicone-based greases in modern cameras mean that winterizing is rarely necessary, though the thick grease in cheaper lenses may make the focusing ring stiff. With most

Combating extreme cold

An oversized parka not only keeps you warm but also leaves room inside it for equipment, which benefits from your body heat. Choose a parka with a front-opening zipper for easy access and plenty of pockets for film and small accessories.

Keep a soft brush handy for flicking snow off the camera. Never blow snow away: your breath will condense and may freeze on the camera.

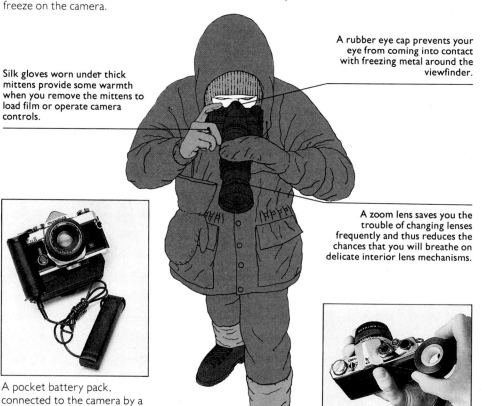

Silk gloves worn under thick mittens provide some warmth when you remove the mittens to load film or operate camera controls.

A rubber eye cap prevents your eye from coming into contact with freezing metal around the viewfinder.

A zoom lens saves you the trouble of changing lenses frequently and thus reduces the chances that you will breathe on delicate interior lens mechanisms.

A pocket battery pack, connected to the camera by a lead as shown above, allows you to use a fully automatic camera in the coldest conditions to reduce camera adjustments to a minimum.

Tape or stick leather over any parts of the camera that your face might touch. Skin may bond to freezing bare metal.

cameras, only the delicate shutter mechanism is likely to cause problems. Again, the answer is to keep the camera warm. Some photographers do this by taping a chemical hand-warming pad to the camera back.

A further danger to guard against in freezing weather is the brittleness of film. Wound quickly through the camera, film can easily crack and will tear under tension. Be especially wary of this when using a motordrive; it may be better to advance film gently by hand. Moreover, if you wind hastily in dry, cold air, you may generate static marks on the film surface. Careful rewinding is even more important, because you risk spoiling exposed film.

Common mistakes

In uncomfortably cold weather it is easy to lose your concentration and make basic errors that will spoil your results. For example, the photographer of the Greenland scene above forgot that she was wearing thicker gloves than usual, and accidentally left the tip of her finger in the corner of the field of view.

Another common mistake, not always obvious through the viewfinder, is to let condensed breath drift in front of the lens. The solution is to hold your breath just before taking a photograph.

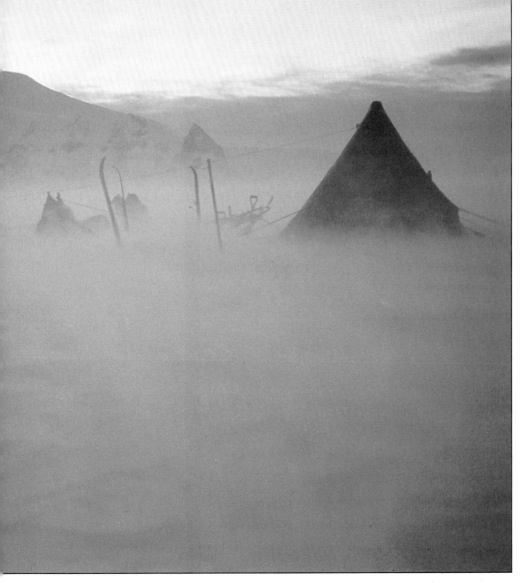

Flurries of snow in Graham Land, Antarctica, blown off a snowfield by swirling winds, evoke the severity of the polar regions. The photographer spent half an hour preparing himself in his tent before venturing outside with his camera.

Ice and snow/2

Exposure meters may be misled by large areas of snow or ice, so in these conditions it is wise to use an incident light reading, aiming the meter at the sky. With a TTL meter take a reading from a gray card or from an 18 percent gray patch sewn into the sleeve of your parka; alternatively, add two stops to your TTL reading. Reflections from snow can sometimes be so bright that the meter needle goes off the scale. If this happens, set half the actual film speed for the reading, and then give one stop less exposure than the meter indicates, to compensate.

Snow and ice can pick up color casts from their surroundings, especially from the blue of the sky. In the picture on the opposite page below, this is a creative bonus. If you want to remove a color cast, you can try using corrective filtration, but it is difficult to judge the exact filter strength required.

Another common difficulty in snowfields is excessively low contrast. To increase contrast in a picture, photograph toward the sun, which will also add sparkle to snow or ice, as in the picture below.

In the very coldest conditions, all films tend to lose some speed, and with color films the varying response of each emulsion layer complicates exposure still further and disturbs color balance. Therefore, you should bracket your exposures; some photographers even switch to color print film for the sake of its extra exposure latitude.

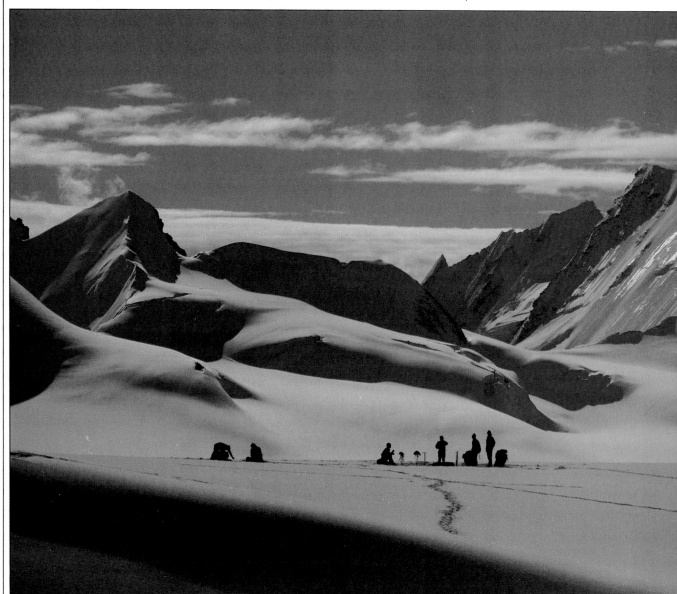

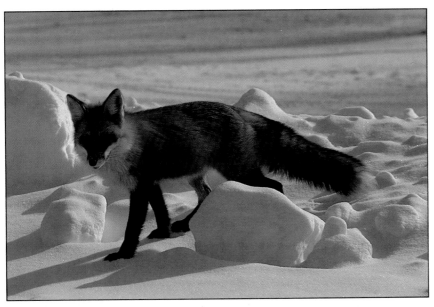

A fox's red coat (left) contrasts in hue and texture with the crisp snow behind it. If the photographer had followed a reflected light reading, the fox might have come out too dark. An incident light meter reading guaranteed correct exposure.

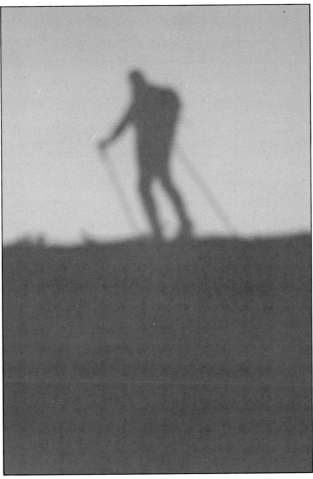

Sunshine over the Himalayas (left) makes a snowfield seem inviting. A careful choice of viewpoint, with the sun in front and to the left of the camera, silhouetted the figures and caused the snow to scintillate attractively.

The shadow of a skier on snow (above) picks up a color cast from the sky, making a simple composition that is deliberately out of focus. Corrective filtration to remove the color cast would have ruined the effect.

Rain and storm

The images on these two pages show the kind of opportunities you can miss if you restrict your photography to dry weather. The atmosphere and light during or just before a rainstorm can be dramatic and, with today's fast films, not too difficult to record. However, you should always take precautions when there is a danger that your camera and lenses will get wet. Keep everything in waterproof bags or cases until required. In drizzle, a camera is unlikely to catch more than a few drops, which can be wiped off with a soft, dry cloth, although it is wise to keep a UV or skylight filter over the lens. For heavier rain, you can make a rainhood for your camera using a transparent plastic bag. Place the bag over the camera body with the lens attached; the opening should be at the bottom to allow access for your hands. Screw your lens hood in place, then cut away the circle of plastic. Or for maximum protection, use an underwater camera.

Lightning can be a fascinating subject to photograph, especially at night. Using a tripod, aim the camera in the direction of the last flash and open the shutter, closing it after one or more flashes. Gauge your aperture by the distance of the lightning: on ISO 64 film, settings between f/11 (very close) and f/4 (several miles away) will usually be successful. If you're caught in the middle of an electrical storm, take shelter indoors or in a car – never under a tree.

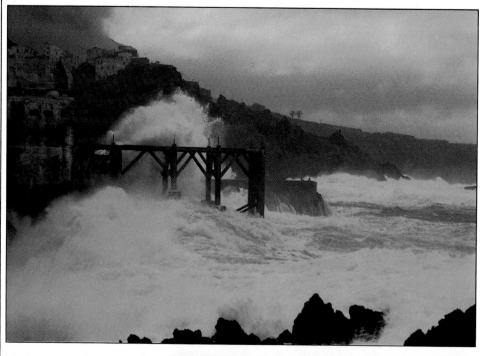

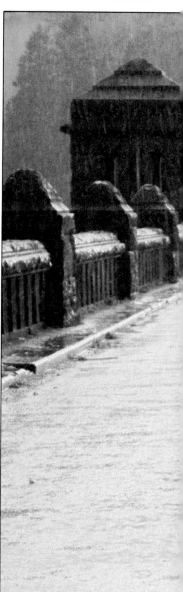

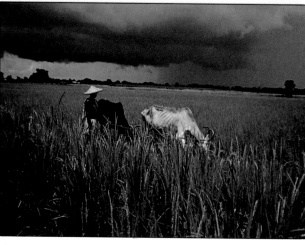

A storm-swollen sea (above) sends waves crashing against rocks. Light piercing the clouds and reflected off the sea allowed a shutter speed of 1/125 to arrest the spray's movement. The photographer used a lens hood and a skylight filter to protect the lens against splashes of sea water.

Inky clouds herald the approach of a monsoon in western Bengal. The photographer carried a waterproof equipment bag in case of a sudden downpour.

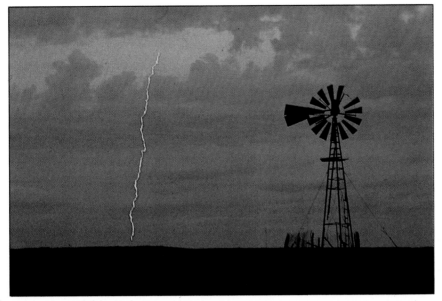

A leaden sky shows a lightning flash, balanced in this composition by a tall windpump. The photographer saw that the storm was moving toward the pump, chose his viewpoint, and waited with the shutter open, closing it after one flash.

Trekkers (below) cross a bridge in torrential rain. The wet stone surface acted as a reflector, revealing detail in shadow areas.

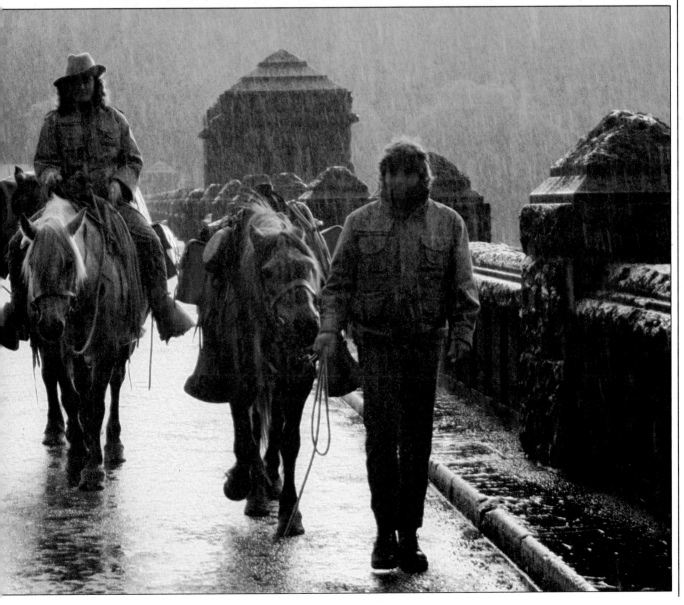

Tropical rain forest/1

The climate of a tropical rain forest poses an even greater threat to photography than does dry desert heat. Although the temperatures are less spectacular, the humidity is often as high as 95 percent. Even when not exposed to rain, equipment in a setting such as that in the picture at right receives a continuous soaking. Steel parts may rust, leather may rot, microcircuitry may fail. Fungus may even grow on the lens, at best destroying the multicoating, or at worst eating into the adhesive between the lens elements.

To keep things cool, you can use the same techniques as for desert conditions. One advantage is that shade is plentiful. But dryness is more difficult to achieve. A sealed equipment case is essential; pack it tightly to exclude humid air, and always surround camera and lenses with packets of moisture-absorbing silica gel, which you can dry out periodically over a slow fire or in a warm oven. If you run out of gel, uncooked rice is a good standby.

Humidity and heat together age film emulsion rapidly and may cause it to swell and become sticky. Images begin to deteriorate as soon as they are captured on film. Keep your rolls of film in their factory-sealed canisters until you need them, and process them as soon as possible. If you return a roll to its canister after exposure, punch a hole in the canister top to prevent the film from sweating; alternatively, keep exposed film in a plastic bag with silica gel, squeezing the air out of the bag first.

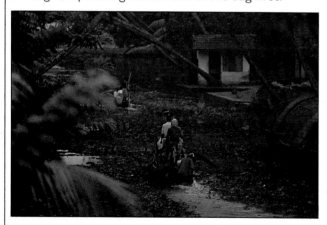

Boats *pass along a canal through a village in India during the rainy season. For photography in heavy monsoon rains, it may be worth using an underwater camera such as the Nikonos, which was popular with photojournalists in the Vietnam war.*

A view of a rain forest *in Ecuador (right) illustrates the extreme humidity that imperils equipment and film. Photographers may encounter similar problems in the Louisiana bayous or the swamps of Florida and Georgia.*

Tropical rain forest/2

To capture on film the special character of a luxuriant rain forest, the photographer faces problems of both viewpoint and lighting. Tangled vegetation may resist all attempts to create a coherent composition with a strong focus of interest. The clearest possible view may be from outside the forest, perhaps from a mountainside, but this approach conveys little of the exotic thrill, tinged with claustrophobia, that a jungle transmits.

One solution is illustrated in the photograph below: aim the camera upward to create a pattern of leaves against the sky. Alternatively, concentrating on a single feature can sometimes convey the jungle atmosphere. This works best with close-ups: middle-distance features often stand out less prominently in a photograph than they do to the eye.

Lighting in a tropical forest is rarely ideal. For views in natural light, you need either high-speed

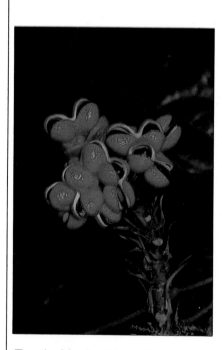

Tropical fruits (above) form a scarlet cluster, attractively offset against dark undergrowth. A small camera-mounted flash unit brought out the brilliant colors of the plant in low light.

film or a tripod. The long exposures needed with slow film may cause reciprocity failure, which alters the color balance and so requires you to use corrective filtration for accurate color rendition. Carry a portable flash unit for close-ups of flowers and wildlife. The close-ups on these pages show how forest gloom can sometimes work in your favor, providing a black or dark-green background to show off bright splashes of color.

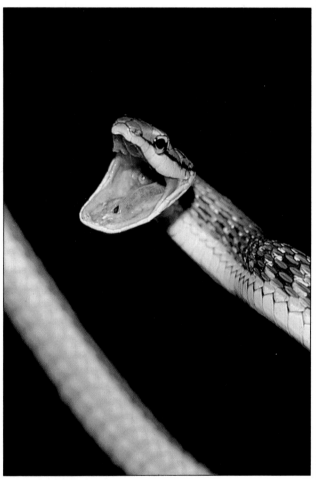

A snake *(above) in the Costa Rican rain forest opens its jaws in a view taken with a 135 mm lens. The lighting came from two flash units positioned close to the subject.*

Fan palms *in the Australian tropics make a graphic pattern against the sky, the backlit leaves contrasting effectively with the silhouetted parts of the scene.*

Underwater photography/1

Taking photographs underwater is far more challenging than any photography you might undertake on land. Not only do you have to keep camera mechanisms and film dry and salt-free, but you must also contend with the fact that water is denser than air, creating problems of increased pressure, optical distortion and low light levels.

A variety of underwater camera equipment is available, some of which is shown at right. The least expensive amphibious cameras function to depths of about 30 feet (nine meters), where the pressure is about twice that on the surface. Never take equipment further than the maximum recommended depth, or water will penetrate the seals and the casing may even collapse.

To remove corrosive salt deposited by sea water, you should follow a stringent cleaning routine after every diving session. If you are using an amphibious camera, soak it in fresh water for at least half an hour, then hose it down with more fresh water. If you are using an ordinary camera in a waterproof housing, follow the same procedure, then, after letting the equipment air-dry, open up the housing and coat the O-rings, or rubber seals, with silicone grease. Never leave waterproof equipment standing in the sun after a dive or condensation will occur inside the case.

You must follow this procedure each time you reload, so use rolls with 36 exposures. ISO 200 slide film yields good results, although slower film is preferable for close-ups. Light meters underwater are unreliable. Always bracket your pictures widely.

As the two pictures at far right illustrate, light refraction underwater makes subjects appear closer and narrows the field of view. To compensate for this, use a wide-angle lens: a 35mm lens has an effective focal length of 47mm underwater. Always focus for the apparent distance, not the actual distance.

Light is absorbed rapidly as depth increases, as shown by the sequence at right. Red is absorbed most strongly, causing a blue cast that intensifies the deeper you dive. At depths between six and 15 feet, you can correct this blue cast successfully using red color correction filters. Calculate the required strength by adding 10CC for every three feet of subject-to-surface and subject-to-camera distance. Keep the subject within about 10 feet of the camera if possible. Note that water that is choppy on the surface absorbs more light than calm water.

When photographing underwater, remember that you are a diver first and a photographer second. Try out your equipment and technique in a swimming pool before venturing into the ocean. Avoid diving alone, and be particularly careful when investigating wrecks.

Light loss
As light diminishes underwater, color falls off from the red end of the spectrum first. At a depth of 10 feet (below top), color is still good. At 20 feet (center), yellow and red are weak. By 40 feet, most light has been absorbed and there is a strong blue color cast.

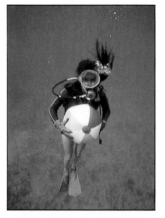

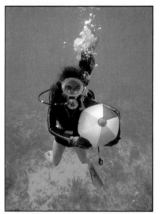

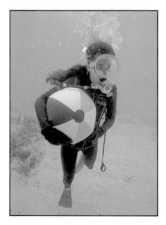

Underwater camera equipment
A wide variety of watertight equipment is available for the underwater photographer. The Sea & Sea 110 Pocketmarine (at right, below) is a simple compact camera with a fixed 20mm lens, built-in flash and a depth capacity of about 150 feet. More sophisticated is the versatile Nikonos camera (at right, above), which has a wide range of accessories and functions in depths down to about 150 feet.

A good alternative to an amphibious camera is a watertight housing such as the Ikelite shown at far right, available in different designs for specific land cameras. Housings are suitable down to about 100 feet, and are available with interchangeable "domed ports" to compensate for the water's refracting effect.

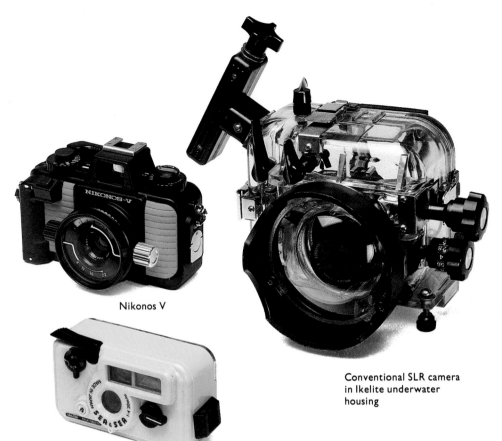

Nikonos V

Sea & Sea 110 Pocketmarine

Conventional SLR camera in Ikelite underwater housing

Refraction

Both the pictures below were taken with the same lens at the same distance from the subject. Underwater, the diver appears closer, because the effective focal length of the lens is increased by 25 percent. Correspondingly, the angle of view and depth of field are reduced.

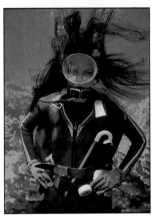

The hull of a wrecked ship frames a tranquil seabed scene. The photographer used a Nikonos camera, bracketing to be sure of getting a correctly exposed image.

Underwater photography/2

Undoubtedly the best introduction to underwater photography is snorkeling. Down to about 30 feet below the surface, ample daylight sustains a wide variety of marine flora and fauna. In tropical regions, coral reefs occur just below sea-level, providing a rich range of subjects that can be photographed from the surface.

For shallow-water photography, you need not invest in expensive equipment. Apart from a face mask, a snorkel and a pair of fins, all you need is a simple underwater housing for your camera, or an amphibious compact camera such as the Hanimex being held in the picture opposite. A built-in or detachable underwater flash unit is useful for fill-in lighting. If you are new to snorkeling, it is advisable to take some lessons before your trip.

For maximum visibility, the water should be clear and calm. The most favorable time of day is between ten o'clock in the morning and two in the afternoon, when the sun is high in the sky. However, even when the light is good you will need to give one or two stops more exposure than you would above water-level. Because it is difficult to keep the camera steady underwater, set the fastest shutter speed that the lighting allows – 1/60 or faster if possible.

Some of the most impressive shallow-water pictures are those taken from a viewpoint looking up toward the surface. On a sunny day, you can adopt this approach to create graphic silhouettes, as on the opposite page, below at right.

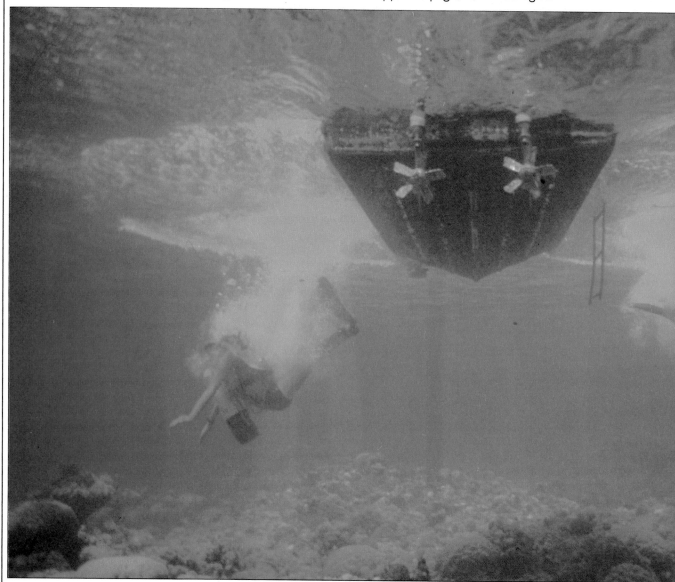

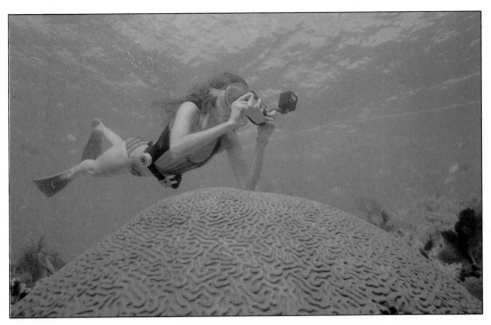

A snorkeler (left)
closes in on her subject with
a compact amphibious camera
and attached flash unit. The
diver's proximity to the
surface preserved excellent
color saturation, even in the
colored stripes of her
swimsuit and the yellow of
her camera.

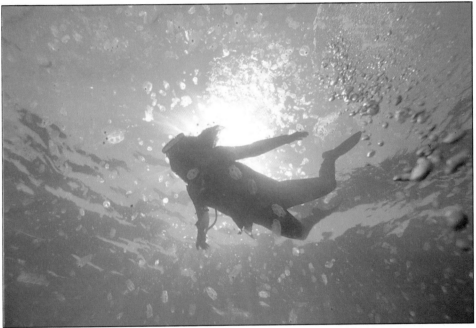

Two divers (left) plunge
into brightly-lit water from
a speedboat. The photographer
steadied himself on a shelf
eight feet below the surface,
where there was sufficient
natural light to allow a
shutter speed of 1/125.

Jellylike blobs of
plankton surround a snorkeler
who is graphically silhouetted
against a sunlit ocean
surface. The bubbles at the
right of the picture, from
the photographer's snorkel,
add a sense of movement to
the image.

Underwater photography/3

Even just a few yards below the surface, you may need flash lighting to capture the vivid colors of fish, coral and other marine subjects at their best. And at depths of 12 feet or more, some form of artificial lighting is essential, as the comparison below at left demonstrates. Although you can sometimes use light from a waterproof flashlight held by a companion, most photographers use either a flash unit built for use underwater, such as the one shown opposite, or an ordinary flash unit inside a water-tight housing.

Always make sure that the flash is held at least 20 inches away from the camera; otherwise, your pictures will show "backscatter," which occurs when a flash burst is reflected off tiny particles suspended in the water, creating bright flecks of light across the image or an overall reduction of contrast. Underwater flash units are provided with long

brackets to solve this problem. But if the water is unusually dense with sediment — as can happen if other divers are around — you may have to hold the flash by hand even further from the camera, or ask another diver to do so.

Judging exposure can be tricky when using flash underwater. As a rough calculation, divide the above-water guide number by four if you are using a rangefinder or viewing screen (which shows only the *apparent* subject distance) or by three if you have set the actual distance. Remember that even the most powerful unit will not penetrate much farther than about 10 to 12 feet. An automatic flash unit simplifies exposure settings, but you should still experiment with a test roll and bracket exposures around the results indicated by the test. If you make your exposure tests in clear water, remember to allow extra exposure when the water is murky.

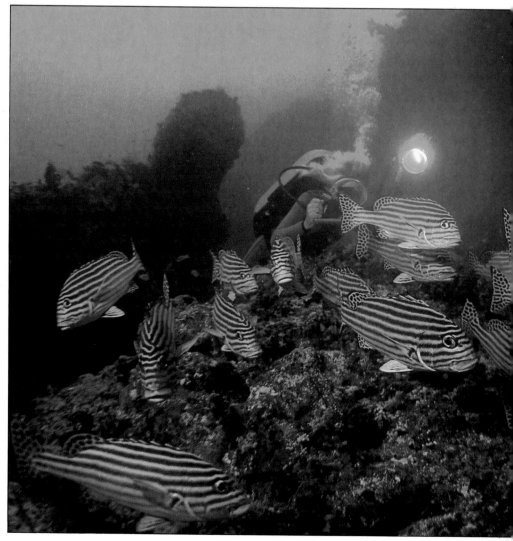

Restoring colors
The coral reef in the picture directly above is dim and colorless when illuminated by available daylight. However, flash lighting reveals truer colors (top).

Underwater flash

The electronic unit at right is fixed to a long bracket to prevent backscatter. The coiled leads allow the flash to be moved even farther away.

Bulb flash has a greater range than electronic flash, but is less convenient to use. Always bring used bulbs back to the surface, rather than littering the seabed.

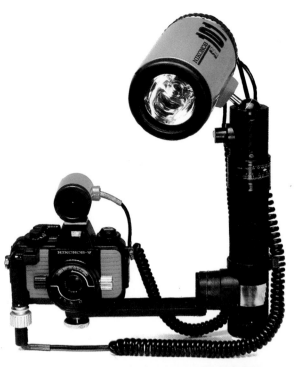

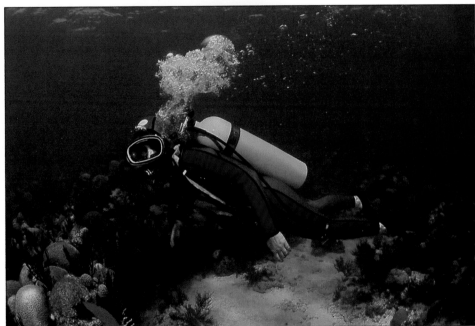

A school of sweetlips (left) flees from a diver equipped with a bulb flash unit on his camera. Additional lighting from another flash unit held by the photographer highlighted the brilliant colors of the fish against the murky background.

A diver in shallow water (above) turns to look at the camera. His flesh tones and the colors of his wetsuit were rendered fairly accurately by a burst from a flash unit, positioned on a bracket above and to one side of the camera to avoid backscatter.

Underwater photography/4

Coral sponges, anemones and seaweed are only some of the incredible variety of marine life that make excellent subjects for close-up photography. The standard technique for framing underwater close-ups like the ones on these two pages is to fit a rigid wire guide to the camera or its housing, as shown below. This enables you to take pictures at a preset distance from the subject and allows you to frame the subject without having to look through the viewfinder – an advantage with non-reflex cameras such as the Nikonos, which would otherwise pose parallax problems at close range.

To take close-ups with one of these "field frames," you can use either extension tubes or supplementary lenses. Extension tubes are relatively inexpensive, but they can be fitted only above water, which means that you are restricted to close-up views for the duration of a dive: this can be frustrating if a large fish swims by. A supplementary lens, though costly, is removable underwater if fitted to an amphibious camera, but not if you are using an ordinary camera in a waterproof housing.

Virtually all underwater close-ups require flash, both to restore lifelike colors and to allow a small aperture setting for maximum depth of field. Fix the flash unit to your bracket, mark off its position, and run a test roll to establish the optimum aperture setting. Off-camera lighting from above usually produces attractive results. You can add a plastic diffuser dome to the flash head to soften shadows.

Using a field frame
A field frame, such as the one at right, is usually sold with a compatible extension tube or close-up lens.
Set the focus on the camera before diving. When confronted with a suitable subject underwater, simply position the wire rectangle as close to the subject as possible, framing as if you were looking into a viewfinder, and then press the shutter release.

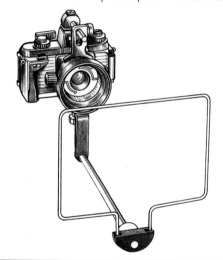

A cleaner shrimp (right) proffers its antennas to the camera in the Caribbean seas around the Lesser Antilles. Using a field frame to ensure sharp focus, the photographer illuminated the scene with a flash unit directed downward onto the shrimp, to create a highlight along the top of its abdomen.

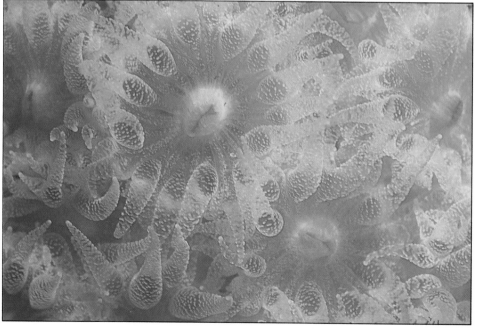

A glowing mass of turret coral (left) fills the frame in an extreme close-up taken by diffused flash.

A tomato clownfish (right) grazes over anemones. The photographer saw the fish darting back and forth, took up position, and then waited patiently for the fish to enter his field of view. He used an SLR camera in a waterproof housing, with a 55mm macro lens.

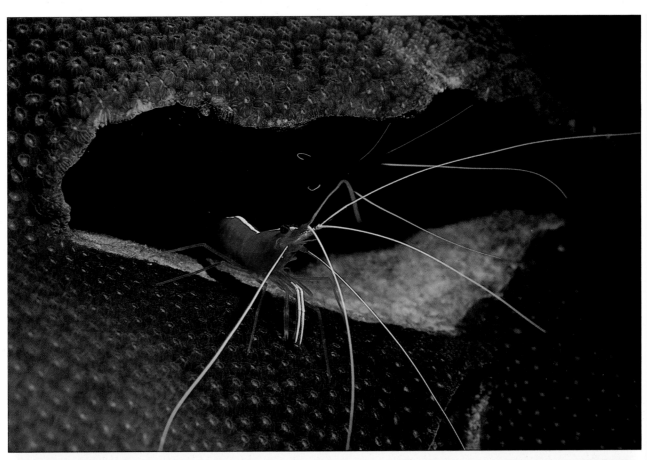

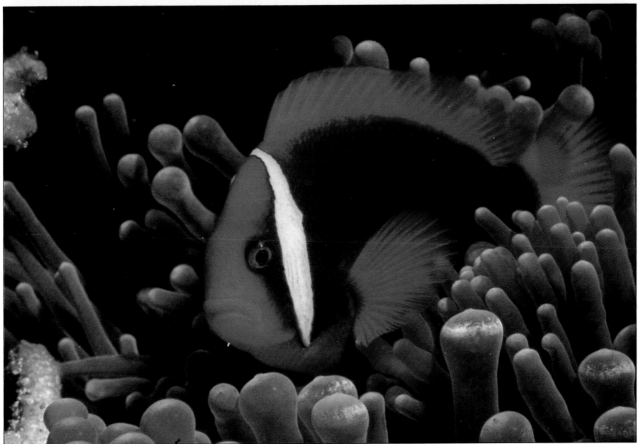

The camera aloft/1

To take successful photographs from a commercial airliner, you need a great deal of luck as well as some skill. As explained in the box opposite, the restricted range of viewpoints is just one of several problems you will encounter. For serious aerial photography, by far the best choice of transport is a light aircraft or a helicopter; hot-air balloons also offer marvelous possibilities, but have limited mobility. However, hiring a plane or helicopter is expensive: to make the best use of your air time, be sure that you have an experienced pilot who will do exactly as you ask.

Photography from a small plane can be difficult in small, irritating ways. For example, wings and wheels may impede the view. These features can sometimes be used to strengthen a composition, especially with a wide-angle lens, as in the picture on the opposite page at right. However, you will more often want a clear view, so a plane with high wings is the ideal choice. Retractable landing gear also helps. Photographing through a plastic window degrades the image quality considerably, so make sure that the window can be opened in flight or the door removed before takeoff, as illustrated below.

Vibration and noise may hinder your concentration at first, but you will soon get used to these conditions. To avoid camera shake, use a fast shutter speed, preferably at least 1/500, and never rest your camera or elbows against part of the plane. Do not allow the camera to project outside the plane where it may be buffeted by the slipstream.

Good communication with your pilot is essential. Arrange a set of hand signals beforehand to signify various simple maneuvers; with the window open or the door removed, conversation is virtually impossible above the noise. Some photographers use hand signals for simple messages and a headset for more complicated instructions.

Using a light aircraft

With a window open or a door removed in flight, it is essential to keep comfortably warm. Wear a parka even if it seems unnecessary on the ground. Silk gloves will keep your fingers warm without hampering dexterity.
Some photographers attach a motordrive to their cameras to avoid wasting time winding on; the extra weight also has a stabilizing effect that is useful with a long lens.

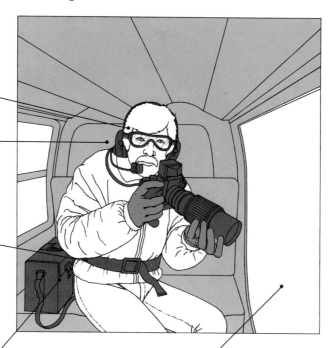

Goggles are useful to prevent your eyes from watering in the inrush of air. But wearing goggles you cannot use a conventional viewfinder; instead, attach a high-eyepoint viewfinder or an action finder to the camera.

A headset facilitates communication with the pilot; check that it is functioning properly before takeoff.

Never be tempted to undo the safety strap to improve your mobility. If you cannot obtain a steep enough viewpoint, ask the pilot to bank.

Strap your camera case to the seat beside you or to the cockpit floor, making sure that you can reach inside it easily.

On many types of light aircraft it is easy to remove the door before takeoff, to permit a wide range of camera angles.

Pictures from commercial aircraft
The best picture opportunities from commercial airliners usually occur just after takeoff or just before landing. In between, airliners tend to fly too high for interesting photographs, although you can sometimes get good pictures of mountain ranges or sunsets. Plastic or glass windows pose a problem. Keep close to the window to avoid a reflection of the camera, and use a large aperture, perhaps with a medium telephoto lens, to ensure that the window surface is out of focus. You may be tempted to use a polarizing filter to darken a blue sky or to penetrate haze; however, as the picture at left shows, this may reveal stress patterns in the window.

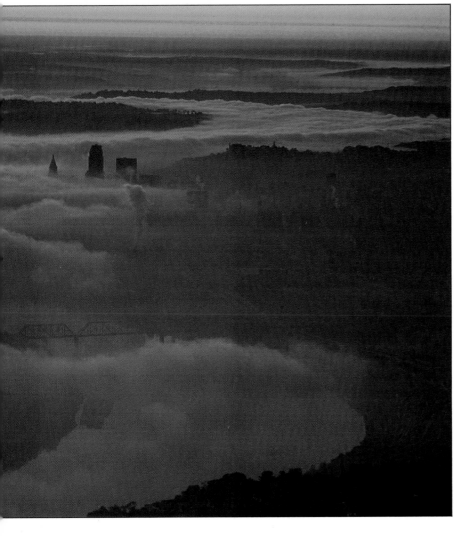

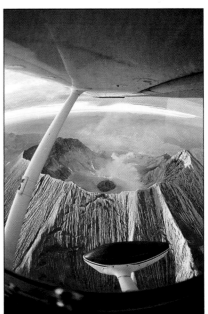

The crater of Washington's Mount St Helens curves dramatically in a wide-angle view (above) framed by the wing, wing strut and window frame of a small light aircraft. The photographer was unable to charter a plane with a window that opened, so for this image he made the most of the restricted view by choosing a 20 mm lens.

An evening panorama of the mist-shrouded Ohio River at Cincinnati, taken with a normal 50 mm lens, amply justified the cost of chartering a single-engine light aircraft.

The camera aloft/2

The quality of light is a critical factor in successful aerial photography. Best of all is a low, bright sun in the early morning or late afternoon. As the pictures below and at the top of the opposite page demonstrate, a raking sun highlights details and further defines the texture of the terrain by means of long shadows, strengthening the visual rhythm of fields, dwellings and other features that make a pattern when seen from above. Moreover, a shadow can help pick out a subject from its surroundings, as in the photograph on the opposite page, below. In bright sunlight, an ISO 64 color slide film is fast enough, and its high resolution helps make sense of distant details. However, some photographers prefer ISO 200 film, allowing faster shutter speeds.

Haze is far more apparent from the air than from the ground. If visibility is severely impaired, even with a polarizing or UV filter on the lens, fly closer to the ground, underexpose slightly and avoid photographing directly toward the sun. Check the local weather forecast before you fly to determine whether clouds are likely to prohibit successful photography.

The standard view is diagonally downward, but it is sometimes worth trying a directly vertical or near-vertical viewpoint. Ask the pilot to bank; this normally leaves you only a few seconds to take pictures, so a motordrive is an asset. In a helicopter, remember that hovering time may be limited if it is windy, even when the pilot can fix his position with a visual reference.

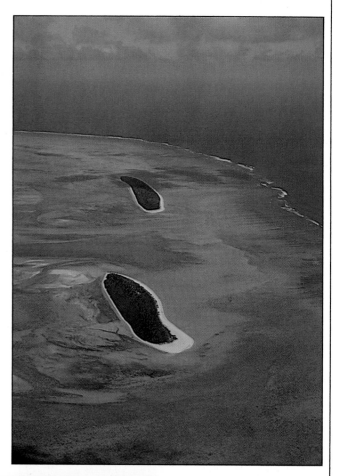

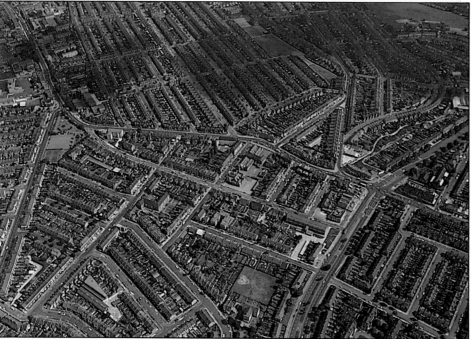

Shallows (above) contribute a wealth of detail to an Indian Ocean view. By including the horizon and distant clouds in the scene, the photographer evoked a sense of space and freedom.

Suburban London from the air reveals an intricate pattern of streets and houses, recorded in fine detail on Kodachrome 64 film. Cloud shadows can often spoil aerial views, but here the sun was not brilliant enough to make the shadows obtrusive.

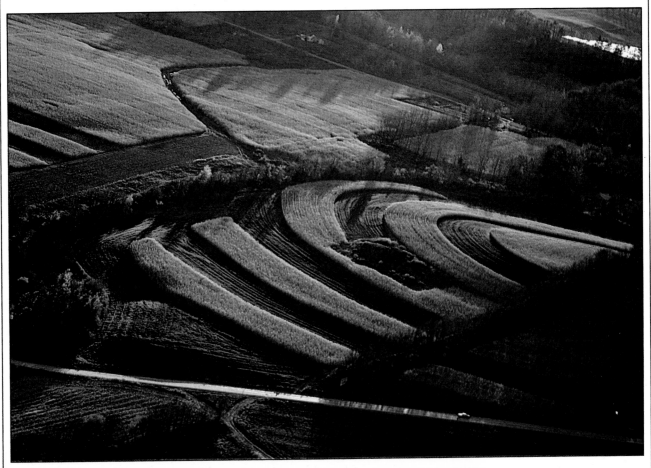

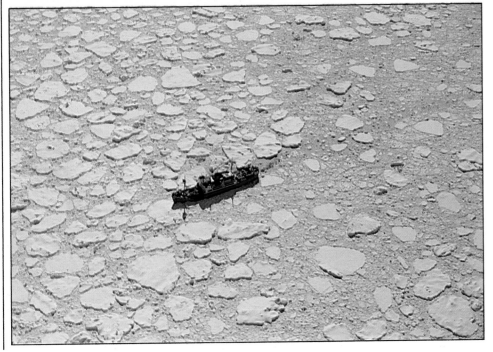

Reflected sunlight on a road and lake add interest to a view of farmland taken early in the morning in bright sunlight. By tilting the camera, the photographer created a more dynamic image.

Pack ice surrounds a ship in the Antarctic. Despite the contrast of the red hull with the expanse of ice, the picture would not have been as successful without the crisp shadows, which draw attention to the ship and emphasize the ice's texture.

Mountain photography

A climber silhouetted against the evening sky hangs upside down as he inches his way across a rock overhang. The photographer closed in with a 100mm lens from a nearby ledge, framing carefully to obtain this dramatic image.

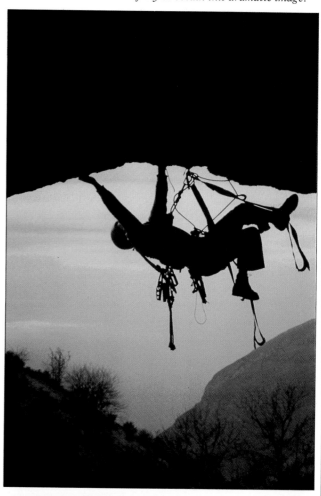

Mountaineers reach spectacular viewpoints from which to photograph some of the world's most magnificent scenery. However, on a difficult climb, when body and mind are fully stretched, taking pictures like the ones on these two pages requires technical know-how, special camera-handling skills and a great deal of determination.

Considerations of weight and bulk, and the anticipated difficulty of the climb, should influence what equipment you carry. You should certainly take a wide-angle lens for dizzying views with an upward- or downward-angled camera and for pictures of climbers in context, and either an 80–200mm zoom or a medium telephoto with a teleconverter for closing in on distant peaks. An autowinder is an advantage in situations where you have only one hand free, although in very cold weather it may damage film. A tripod is useful, but a less cumbersome alternative is a clamp and ball-and-socket attachment for mounting the camera on the handle of an ice-ax. To reduce ultraviolet haze at high altitudes, a strong UV filter is essential. Carry your equipment in a hip bag, as described below. When climbing above the snow line, follow the advice given earlier in this book (pages 22–5) on coping with ice and snow. Thin air causes shortage of breath after only mild exertion; always recover your breath before taking a picture, or there will be a danger of camera shake.

Before an expedition, test your camera rigorously to make sure that all functions are working properly. Use practice climbs to test not only your ropework but also your camera-handling techniques.

Carrying camera equipment

To protect equipment from knocks and jolts, while leaving it accessible, hip bags like the one shown below are ideal. Made of strong nylon, they are waterproof and leave the arms and shoulders free.

When wearing a camera around your neck, never let it swing freely or it may get damaged. Restrain its movement with dog clips fastened to the shoulder straps of your backpack. Or wear an elastic chest band over the camera's neckstrap, as at right.

Most hip bags have internal compartments for storing camera, lenses, accessories and film.

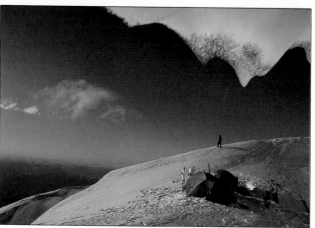

At a camp high in the Pamir range of northern China, a mountaineer surveys the distant panorama. A 35mm lens took in this view. To help cut through the early evening haze, the photographer used a polarizing filter.

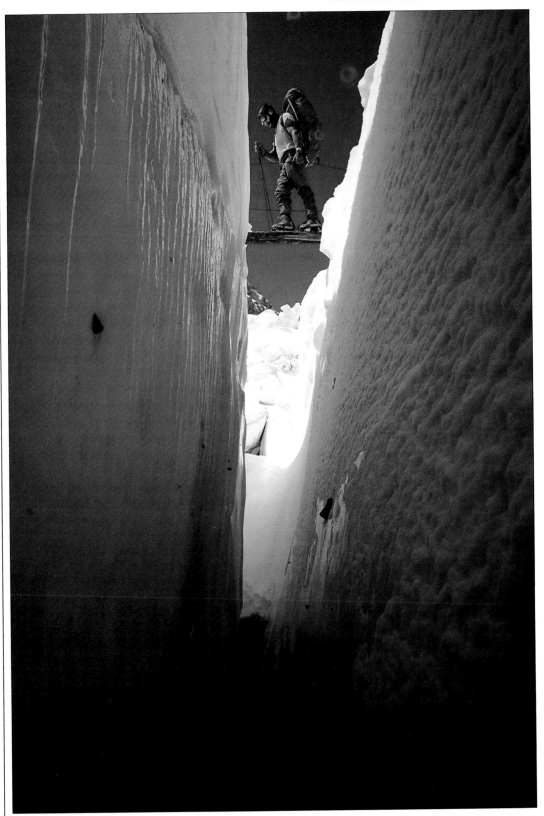

Crossing a crevasse on Mount Everest, a climber is framed against a deep blue sky. The photographer took a meter reading from the back of his hand before descending into the crevasse to take this view with a 20mm lens.

Photography underground/I

In some regions of the world, there is a rich and unfamiliar landscape beneath the ground. However, if you decide to photograph this subterranean environment, remember that caves are full of dangers and discomforts, as the pictures here show. Never venture into a cave without an experienced caver to guide you, and even if you have some experience, never enter a cave alone. Sturdy boots, a safety helmet with a lamp and spare bulbs, and tough outer clothing are essential. A wet suit will keep you warm if you encounter water. Always make sure that someone above ground knows exactly what you plan to do.

Photographic equipment and materials need protection, not only against rough handling but also against mud (which can scratch optical surfaces) and water; a resilient, waterproof case, well padded inside, is therefore essential for carrying your camera and lighting equipment. Most caving photographers use only one lens, as lens-changing underground is ill-advised. All the photographs here were taken with a 50mm lens, although a 35mm lens is a more usual choice. A tripod, although cumbersome, is essential when making long exposures for "painting with light" (as described on page 48). An ex-army rocket tube makes an ideal tripod container.

Equipment cases

A conventional photographic equipment case is not strong enough for caving conditions. However, you can improvise a damage-proof case by converting an ammunition box, obtainable from an army surplus store; two of these boxes are shown below, alongside flashbulbs and a custom-built slave unit. Strong carrying straps are essential. Some photographers paint their cases white, or stick reflective tape to them, to make them easier to locate when covered with mud. To protect equipment from knocks enclose it in "bubble-wrap" material. Avoid foam, which absorbs water.

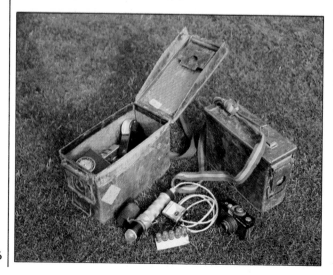

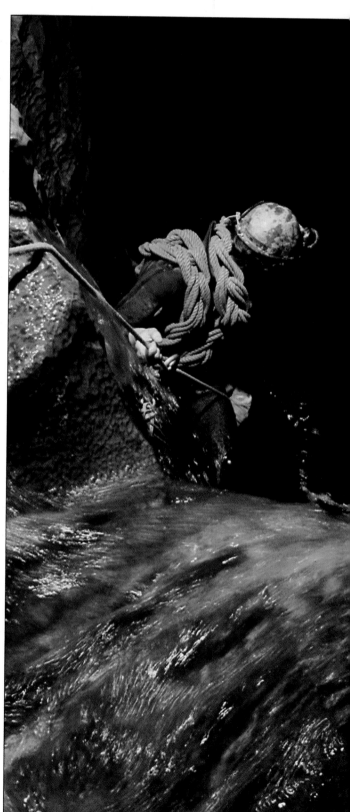

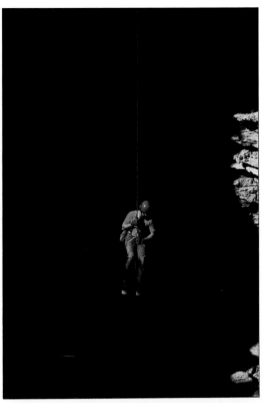

Using harness and rope (left), a caver maneuvers himself into position as bright sunlight illuminates him against the dark mouth of a cave. As this picture shows, you often need some climbing skills before you can venture underground.

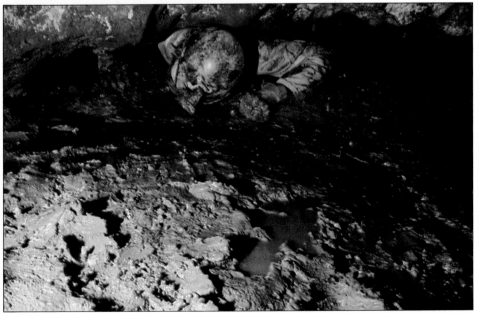

Looking down a waterfall shaft (left), a caver prepares to enter a cave system. The photographer placed his camera securely in a waterproof equipment case and lowered it down the shaft before making the descent himself.

A caver caked in mud slithers through a narrow crevice. To ensure that no gritty particles of mud scratched the camera lens, the photographer kept a skylight filter permanently in place.

Photography underground/2

To photograph rock landscapes like those shown on these two pages, cavers must provide all the illumination themselves: except at cave entrances, there is no available light. Flash bulbs are more practicable than electronic flash, because they are more robust, more powerful and provide a greater spread of light. For either type of lighting you should divide manufacturers' guide numbers by at least four as a starting point for bracketing. One common strategy is to equip each member of a team with a flashbulb and to get them to fire all the bulbs simultaneously while the camera shutter is held open, as the photographer did for the picture on the opposite page and the one at right. Because exact synchronization is unnecessary in these circumstances you can coordinate the firing of the flashbulbs simply with an oral countdown. Including human figures in the view contributes a sense of scale and also provides a memorable record of a caving team's achievement.

To illuminate a large cavernous interior, try the technique known as "painting with light." First, choose your viewpoint and set up the camera on a tripod. Then, with the shutter open on the B setting, move around the cave firing flashbulbs at intervals. Shield the flashes from view either behind your body or, to avoid creating silhouetted self-portraits, behind projections in the cave walls.

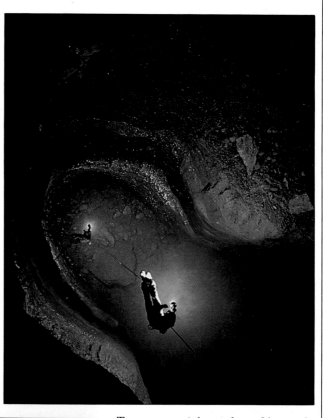

Two cavers (above) descend into a pit, each pausing to fire a flashbulb at the photographer's instruction. The overhead viewpoint, achieved by the photographer hanging from a rope, helps give the image a semi-abstract quality.

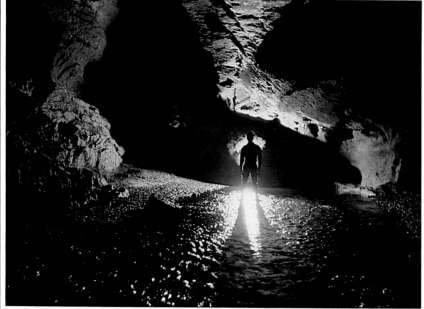

A dramatic silhouette and shadows (above) add drama to a view illuminated by a flashbulb concealed behind a standing caver. A wide-angle lens exaggerated the perspective of the shadows thrown by his legs.

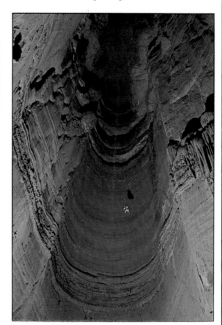

Dwarfed by a vast chimney (right), a solitary figure descends on a rope. The photographer used magnesium flash-powder to illuminate the cave. He poured a film can of powder onto a sheet of paper, lit the edges and stood well back.

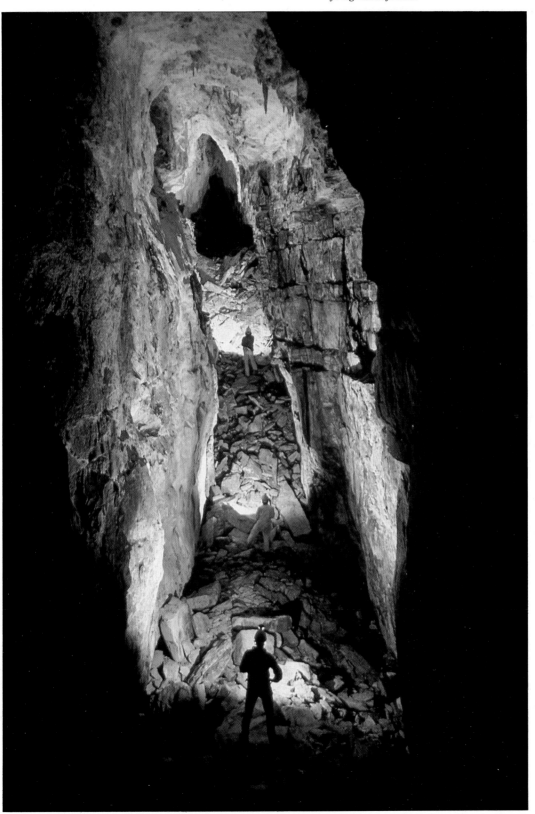

A rock-strewn chasm is revealed by three members of a caving team, each holding a flashbulb. The photographer omitted a fourth flash near the camera, because he wanted to create a dark foreground frame.

Sailing photography/1

Exhilarating action, combined with the sleek beauty of the craft and the sparkle of a sunlit sea, can make sailing and windsurfing among the most photogenic of sports.

One of the most satisfactory approaches is to use a motorboat, which must be large enough to provide a relatively dry and stable platform for photography, yet fast enough to get ahead of the craft for the optimum viewpoint. However, never use a motorboat without obtaining the full cooperation of your subjects beforehand. The driver must have a thorough knowledge of sailing, or your activities may be dangerous as well as a nuisance.

Handling a long lens on a rocking boat requires practice. British sports photographer Alastair Black,

who took all three pictures shown here, can use a 200 mm lens at sea without difficulty. But common faults among beginners are camera shake and sloping horizons. An 80-200 mm zoom prevents your having to change lenses, but most zooms are heavier and slower than telephotos within the same range.

A waterproof camera, such as the Nikonos used for the picture below at left, is useful for photography from water level, although this strategy can be dangerous unless you are working with an experienced sailor or surfer. If you are using a land camera from a boat, keep the camera under a front-opening parka, taking it out only when you need it. Keep your back to the spray and turn around between waves to take pictures.

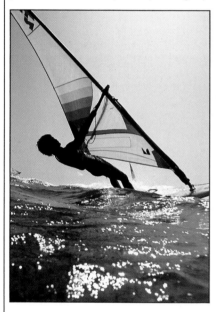

Leaning close to the water (above), *a windsurfer skims the waves in a dramatic close-up. The photographer who was just a few yards away, wore a wetsuit and fins. He kept his underwater camera just above the water by resting his elbows on a small air mattress, as diagrammed below.*

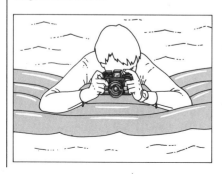

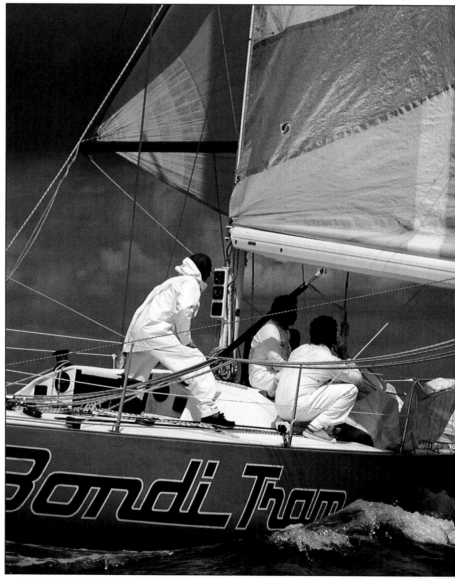

Pictures from the shore

If you want to fill the frame with the drama of sailing or windsurfing, the possibilities from dry land are limited. A breakwater will sometimes bring you closer to the subject, but even a long telephoto lens will seldom provide the magnification you need. For dramatic pictures such as the one below, at right, use a long, fast telephoto (at least f/5.6) in combination with a teleconverter. The illustration at right shows a 600 mm lens and a 1.4× converter, which together offer an effective focal length of 840 mm. With this approach, a good tripod with a smooth panhead is essential.

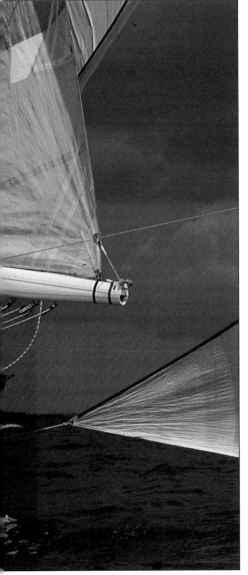

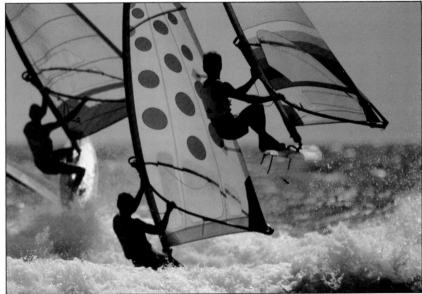

A trio of windsurfers (above) bounces dramatically above the surf off Hawaii. This picture, which in Britain won Alastair Black the Sports Photographer of the Year award (1983), was taken from the shore with a 600 mm lens used with a 2× converter. A shutter speed of 1/250 froze the action.

Yellow and white sails stand out brilliantly against a leaden sky. The photographer, using a 105 mm lens from a motorboat, waited for the sun to peep through the clouds to add sparkle to this composition. A skylight filter protected the lens from salt spray.

Sailing photography /2

One of the most effective ways of photographing large sail boats, as the pictures below and on the opposite page at left demonstrate, is from a light aircraft or a helicopter. This approach makes it easier to reveal the boat's whole structure, including the often graceful shape of the deck. And the extra speed you gain in the air greatly enhances your ability to move into position around a boat.

To a great extent, taking pictures of sail boats from the air demands the same techniques as do other forms of aerial photography. However, there are some additional considerations. To obtain the

best viewpoints, your pilot must be able and willing to fly in low and circle tightly around the boat: even a large boat makes a relatively small target from the air. The most dynamic compositions are those in which the boat almost fills the image area and is partially cropped by the picture frame, as in all the images here. But you must avoid coming *too* close, or you may interfere with sailing. Many racing crews dislike helicopters, because their engine noise can easily drown vital commands shouted by the crew. Moreover, the downdraft from a helicopter's whirling rotor blades can cause severe air turbulence; to

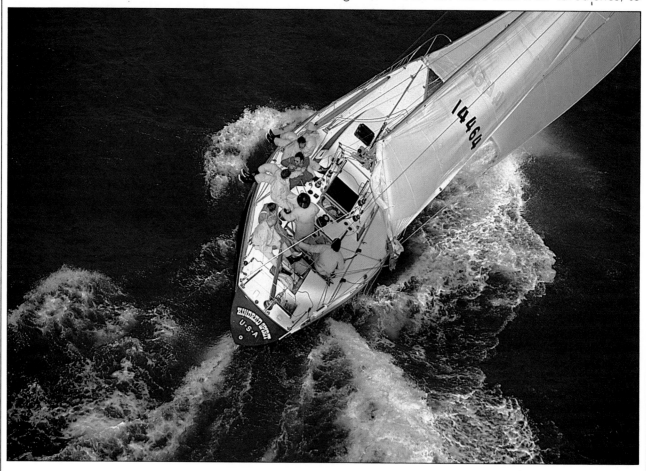

A yacht surges through the waves, making a strong, diagonally-based composition. The photographer took the picture with a 180 mm lens from a helicopter, which hovered very briefly just astern of the yacht. The helicopter's door was removed to allow a clear view.

avoid this danger, always keep well astern or to the side of the yacht.

Make detailed arrangements beforehand with the captain of the boat you want to photograph; or, if you want to cover a race, contact the organizer of the event. The best method, because it is the least disturbing to the sailors, is to ask the pilot to move in and out of range, and take your pictures as quickly and efficiently as possible, using a motordrive. An 80-200 mm zoom lens will help you achieve optimum framing very rapidly. However, you can easily lose focus when zooming, so it may be preferable to use two camera bodies, each with a lens of a fixed focal length – say, 100 mm and 180 mm.

Another way to get an overhead viewpoint is to have yourself winched up the mast when the boat is at anchor, as the photographer did for the photograph shown below at right. For action views, you can strap the camera with a motordrive to the masthead and operate it from below by a long electric cable-release. This can produce dramatic storm pictures, but you must protect the camera adequately, either by an underwater housing or by an improvised plastic rainhood.

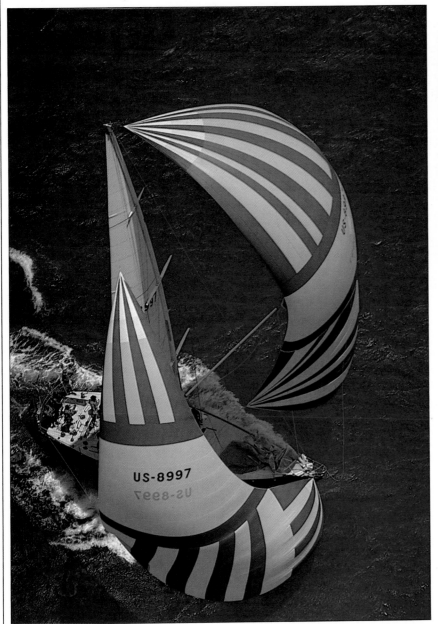

A tropical beach (*above*) is the setting for an unusual view of a yacht, taken manually from the mast 80 feet above deck level.

White and green sails stand out sharply against the deep blue of the sea in the aerial photograph at left. The photographer used one stop less exposure than his TTL meter indicated to compensate for the dark background.

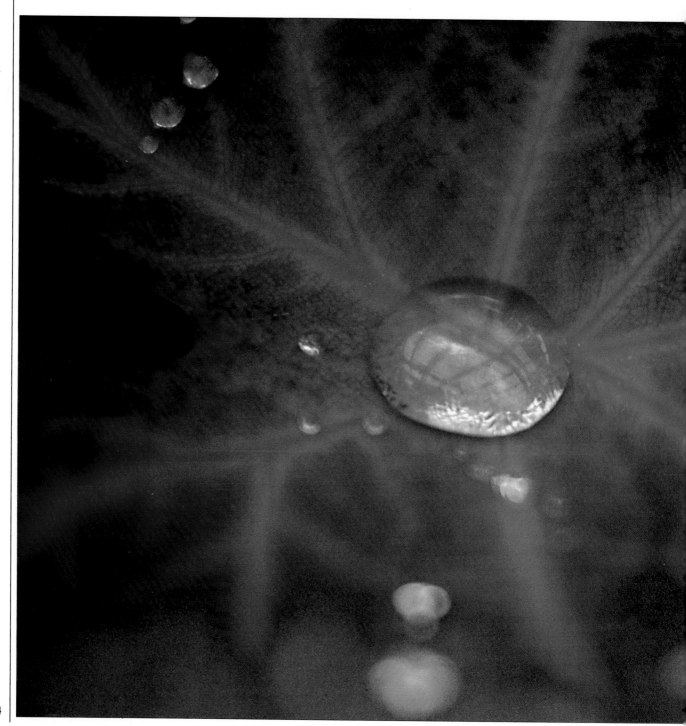

THE EXPERT EYE

To the amateur, certain specialized types of photography may seem attractive yet daunting. For example, many camera-owning nature lovers feel inspired by close-up images such as the one at left, but refrain from attempting close-ups themselves because they feel that the techniques required are too complex.

Behind this reluctance is the feeling that some fields of photography are the monopoly of professional specialists who have spent years developing sophisticated solutions to unique problems. But there is no reason why the enthusiastic amateur should not benefit from the achievements of the specialist, even if in a modest way.

This section examines some of these special areas – like working with remote-control cameras and photographing stage performances and museum exhibits – and sheds light on their apparent mysteries. The problems encountered vary widely from one field to another: they may have to do with scale, lighting, subject distance, or any combination of these factors. To tackle such challenges you may have to invest in new equipment – perhaps a powerful telephoto lens, or one of the more versatile types of tripod. However, just as important are a dedicated attitude to problem-solving and a willingness to learn from your mistakes. Persist in your attempts to master a specialized technique, and your reward will be a new way of experiencing the world of photography – with the eye of an expert.

A water droplet in the center of a red-veined leaf dimly reflects the frame of the surrounding greenhouse. The photographer used a 55mm macro lens at a wide aperture to deliberately blur the foreground.

Being prepared

One skill that all professional photographers eventually acquire is an ability to cope with unexpected situations, improvising on-the-spot solutions to whatever problems they meet with. It is in locations far from home that such improvising skills tend to be called upon most frequently. Local inhabitants, or the landscape itself, may sometimes yield an answer to a problem. For example, you may be able to borrow a white sheet to use as a makeshift reflector, or you might collect a handful of rocks and suspend them in a bag from the tripod head to steady a lightweight tripod. But it is risky to rely entirely on materials that just happen to be available. So, to increase their options for problem-solving, many professionals carry (in addition to a blower brush and lens tissues for cleaning) an emergency kit made up of tools and other items that they know may be useful in the circumstances they are likely to encounter.

A few such items, many of them with familiar household uses, are illustrated on these two pages. Equipment that is versatile, lightweight and cheap is

General equipment for problem-solving
Most of the items shown here are particularly useful for support or protection, or for making small adjustments to subjects or backgrounds. For example, you can use an elastic luggage strap to keep an overhanging branch out of the field of view. Fishing line used as a support has the advantage of being inconspicuous even when it appears within the frame. A string bag, which you can fill with heavy objects, is useful for stabilizing a tripod. A zip-top toolbag is ideal for packing this kind of general problem-solving equipment.

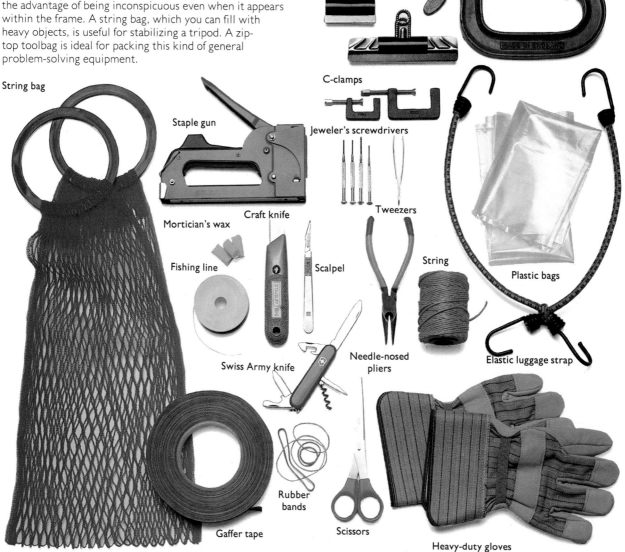

Spring-grip clamps

G-clamp

C-clamps

Jeweler's screwdrivers

String bag

Staple gun

Tweezers

Craft knife

Mortician's wax

Fishing line

Scalpel

String

Plastic bags

Swiss Army knife

Needle-nosed pliers

Elastic luggage strap

Rubber bands

Gaffer tape

Scissors

Heavy-duty gloves

always preferred – for example, gaffer tape, which is useful for attaching lights to all kinds of surfaces and for setting up equipment for remote-control photography. A pair of tough gloves has many uses, from climbing a jagged rock for a high viewpoint to clearing away vegetation for a nature close-up. Tools such as tweezers and needle-nosed pliers can be handy for simple repairs to photographic equipment as well as for delicate adjustments to close-ups or still-life set ups. To tighten the minute screws on cameras and lenses, which occasionally loosen, carry

a set of jeweler's screwdrivers, shown on the opposite page at center. One of the most versatile items is a Swiss Army knife, which has a variety of retractable blades, as well as scissors and tweezers.

You must also be prepared for problems of lighting. A location studio kit for indoor or outdoor use should contain both diffusing and reflective materials, as described below. Sheets of gel may be useful for manipulating a light source: yellow, blue and magenta for modifying the color temperature, neutral-density for reducing the brightness.

Equipment for solving lighting problems

The Lastolite shown below, which folds to the size of a small bag, is one of many types of white reflector available. A space blanket, sold by camping stores, can serve as an improvised foil reflector, while a carefully angled dentist's mirror can add a highlight to a reflective subject. Two alternative methods of synchronizing two or more portable flash units are shown here: most convenient is a photo-cell slave trigger, but you could also use a sync junction with remote leads (or just a coaxial plug with wires).

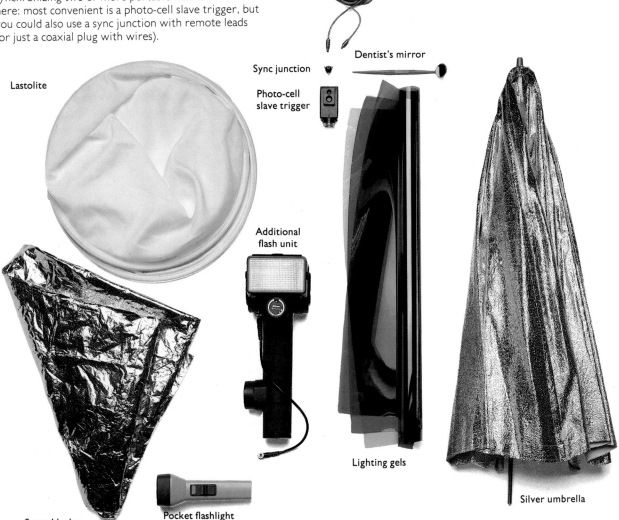

Sync lead

Dentist's mirror

Sync junction

Photo-cell slave trigger

Lastolite

Additional flash unit

Lighting gels

Silver umbrella

Space blanket

Pocket flashlight

Using long telephoto lenses

A parasol and three posts of a wood fence offer a teasingly selective view of daily life in Bangkok. Using an 800mm lens, the photographer prefocused on the fence and waited for the passerby carrying the parasol to enter the field of view. He used a cable release with the tripod-mounted camera to avoid the risk of camera shake.

Road markings, street lights and shadows form a complex pattern in a view of Basin Street, New Orleans, taken from a high window with a 600mm lens. A double tripod support ensured stability. After taking several horizontal views, the photographer shifted to the vertical format by rotating the camera and lens within the tripod collar.

Lenses with a focal length of 200mm or longer can record distant subjects with an extraordinary clarity and intimacy, as in all three pictures here. But the bulk and weight of these lenses, and their shallow depth of field, narrow angle of view and relatively small maximum aperture, call for special handling.

One problem is vibration. A lens with a long, broad profile is so sensitive to air currents that even a slight breeze may move it. The greater the magnifying power of the lens, the greater will be the effect of such movements on the sharpness of the image. A shutter speed of 1/500 or 1/1000 will allow you to handhold the camera without risk of blur even with lenses up to 600mm in focal length. However, the maximum aperture of a long lens – commonly f/4.5, f/5.6 or f/6.5 – seldom allows such fast speeds, and for most situations you must provide support. Even with a tripod, additional precautions may be necessary, as described in the box opposite.

With powerful telephoto lenses, focusing is critical. Ordinary focusing screens may not be accurate enough, and focusing aids such as microprisms and split-image rangefinders tend to black out unless the lens is f/4.5 or faster. It is preferable to fit a plain mat screen without focusing aids. Alternatively, some manufacturers supply screens with focusing aids specially matched to the characteristics of long lenses. For action photography, it may be worth buying a "follow-focus" lens, with a squeeze-grip focus control.

Once set, the focus can shift with the lightest accidental touch. To overcome this problem, many long telephoto lenses have a focus-locking screw.

Supporting long lenses

Long telephoto lenses usually have a tripod socket that enables you to support them at the point where the camera-lens combination balances. Lenses with two tripod sockets, one for horizontal and one for vertical views, are less convenient to use than the type with just one socket on a rotatable collar. With a large lens such as 600mm, additional support from a second tripod, as shown at right, is a sensible safeguard against camera shake. On a windy day, set up the camera in a sheltered place and splay the tripod legs as wide as the design permits.

A broad, solid surface such as a rock may offer better support than a tripod. Place a rolled-up garment or other padding between this surface and the lens.

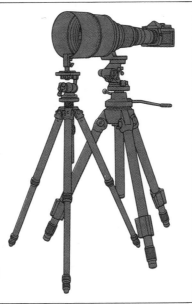

A hippo yawns gigantically in a view taken with a 600mm lens in an African game park. Because the lens was of the internal focusing type, which produces a significant change of focus with only a small twist of the lens barrel, the photographer was able to focus quickly on the hippo when he saw that it was about to yawn.

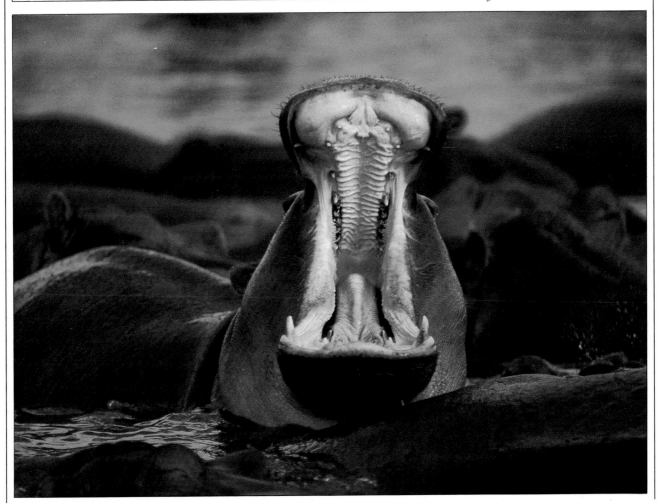

Closing in /1

A normal 50mm lens for a 35mm SLR camera will focus down to about 18 inches, so for closer distances, and correspondingly greater magnifications, special close-up equipment is necessary. The range of equipment available may seem bewildering to the uninitiated. To penetrate the apparent mysteries, the first thing to grasp is the basic principle underlying all close-up photography: namely, that the magnification of a subject becomes greater as the distance between the film and the lens increases, or as the focal length decreases. The devices that put this principle into practice are shown in the comparison chart below, along with their advantages and drawbacks. Your choice will depend on the range of magnifications you need, as well as on the image quality you require and on how much you are willing to pay. The choice may also depend on the equipment you already own. For example, if you need a lens for normal subject distances as well as one for close-ups, it may be worth buying a 50mm macro lens, which can handle both.

The best introduction to close-up photography is a set of supplementary close-up lenses. These screw into a regular lens just as a filter does, and reduce

Close-up equipment

The chart on these two pages shows five different means of obtaining magnifications greater than those possible with a normal 50mm lens used without any close-up attachment. For each item of equipment, a typical range of magnification is specified. The picture at the bottom of each column is a characteristic image taken by the means described. The subject in all five views is a pussywillow in blossom.

Supplementary close-up lenses

Close-up lenses, sold singly or in sets of three, are compact and inexpensive. Their strength of magnification is measured in diopters: to work out how close the lens allows you to focus, divide the diopter value into one to yield the distance in meters. Two close-up lenses may be combined for extra magnification, but with loss of image quality. No light is lost as it travels from lens to film, as it is with extension tubes and bellows. TTL metering and automatic-exposure setting work normally.

0.08x to 0.3x (normal 50mm lens with one close-up lens)

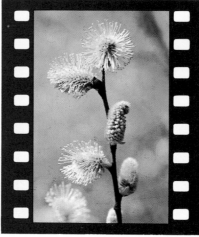

0.25x

Extension tubes

Individually, extension tubes extend the lens-to-film distance between 5mm and 30mm, but they may also be combined for greater magnification. Because there are no optical components to distort the performance of the prime lens, extension tubes offer better image quality than close-up lenses. However, they cause effective loss of speed: a 50mm lens on a 50mm extension loses two stops. TTL meters still operate, but automatic metering is possible only with "auto" extension tubes.

0.1x to 2x (normal 50mm lens with three extension tubes)

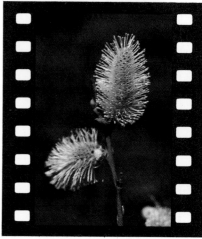

0.4x

its focal length. Although a close-up lens may produce a loss of sharpness at the edges of an image, this is not always a problem if you can keep the main zone of interest in the center of the frame.

Extension tubes and extension bellows magnify the subject by physically extending the lens-to-film distance. Both can be used with a normal lens. Sometimes, you can improve image quality by mounting the lens on the bellows or extension tubes in the reverse position, using a reversing ring – a method that is particularly effective with wide-angle lenses. By using extension tubes with a 105mm or 135mm lens, you can obtain an enlarged image without having to move in close to the subject; this can simplify lighting. However, bellows units, because of their flexible construction, allow you to vary the magnification over a continuous range.

Few serious close-up photographers are without one or more macro lenses. Most of these lenses produce magnifications up to half life-size – or more when combined with bellows, extension tubes or supplementary close-up lenses. Macro zoom lenses rarely focus to such short distances as fixed macro lenses and may be optically much inferior.

Macro lenses

Macro lenses are sold in a range of focal lengths, the most popular being 50mm and 55mm; 100mm and 200mm are also useful because they offer a greater working distance. Designed for optimum performance at close range, macro lenses can also be used at standard distances, but are slower than normal lenses, often with a maximum aperture of f/3.5. They can be used with a range of close-up equipment. When a macro lens is fitted directly to the camera, exposure metering systems function normally.

Bellows with 50mm lens

Most bellows stretch between 100mm and 200mm and thus offer greater magnification than extension tubes, as well as a wider range of options. As with extension tubes, increasing the lens-to-film distance reduces the light reaching the film. Automatic metering is sacrificed, except on cameras with meters that take a reading from the film surface. However, a TTL meter can be used if the aperture is stopped down manually. A bellows usually costs about twice as much as a set of extension tubes.

Bellows with special bellows lens

Special macro lenses called "bellows lenses" are made exclusively for use with a bellows; there is no focusing mount, so they cannot be used directly on the camera. Magnifications up to 6x are possible with a 35mm bellows lens, and up to 10x with a 20mm lens. A 20mm lens with an extra-long bellows will even yield 20x. At such extreme magnifications, the image may be eight stops dimmer than an image taken with the lens set at infinity; flash is therefore an essential accessory.

Up to 0.55x (50mm macro lens)
Up to 1x (50mm macro with extension)

0.7x to 3.5x

3.5x to 10x (bellows with 20mm macro bellows lens)

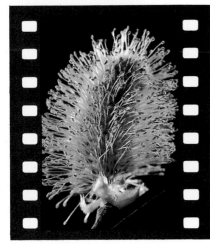

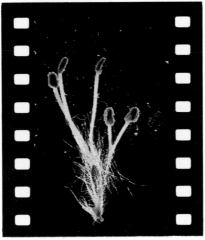

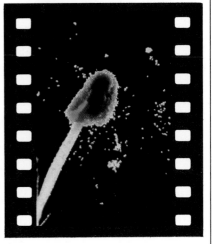

1x

3.5x

10x

Closing in /2

In macro photography, depth of field is greatly restricted, and it may even be virtually zero at high magnifications. This makes it essential, for most close-up work, to mount the camera on a tripod – not only to allow a small aperture but also to ensure that the camera-subject distance remains absolutely constant between focusing the lens and releasing the shutter. If possible use a heavy tripod. The prospect of carrying it may seem daunting if you anticipate having to walk any distance from your car; however, lightweight tripods offer considerably less stability. Choose a tripod with a reversible center post, for the option of a low viewpoint, and with independent leg movements for photography on uneven terrain. Alternatively, some tripods can be stretched out until the camera is just a foot or so from the ground if you remove the center post. A tripod with a ball-and-socket head usually permits delicate adjustments to the camera angle more easily than does the pan-and-tilt type.

Without artificial light, a small aperture requires a slow shutter speed, introducing the problem of subject movement. At high magnifications, even a slight movement will produce an unsharp image. However, an improvised cloth windbreak may help.

The low raking sunlight of early morning or late afternoon is generally unsuitable for close-ups, except for backlighting a colored translucent subject, or for semi-abstract effects like the one opposite, above. For revealing detail in pale-colored subjects, the diffused light of an overcast day is preferable. On field trips you should take along a selection of reflectors to boost low light levels and diffusers to modify direct sunlight, as described below. Use a lens-hood to eliminate flare, which is a greater danger with close-ups than with ordinary subject distances. Try to avoid locations where sunlight filters down through green leaves, or you may get an obtrusive green color cast, which will be especially noticeable with a white subject.

Setting up a close-up in available light
Although flash is a useful tool for the close-up photographer (as explained in detail on pages 64–5), you can successfully photograph plants and other relatively motionless outdoor close-up subjects in available daylight. An efficient procedure for doing this is described in the step-by-step sequence at right.

Fishing line is useful for supporting plants; you may also wish to make your own plant clamp with a spike that you can drive into the ground. Equipment should also include: a cloth windbreak with spiked poles; a white cardboard reflector; muslin or similar diffusing material; and pieces of colored cardboard to serve as uncluttered, out-of-focus backgrounds.

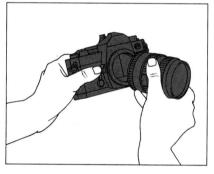

1 – Select the close-up attachment according to the required magnification. Decide on an approximate viewpoint and framing, then set up the camera and lens on the tripod. Screw in the cable release. Frame and focus the image.

2 – If necessary, stabilize the subject and shelter it from the wind. Adjust the background, removing unwanted details from the field of view. Check the viewfinder and make further adjustments until you have the composition you want.

3 – Judge the quality of the available daylight and decide whether you need to use a reflector to fill in shadows or a diffuser to spread and reduce the intensity of light. Arrange these lighting aids and preview the effect.

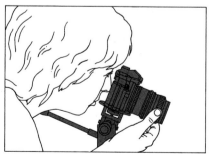

4 – Check the focus, then set an aperture that gives you the required depth of field. Stop down the aperture to preview the depth of field in the viewfinder. If necessary, adjust the aperture setting.

5 – With the lens still stopped down to its working aperture, take a TTL meter reading. With extension tubes or a bellows, allow extra exposure, following the instructions on page 64. Take the picture using the cable release.

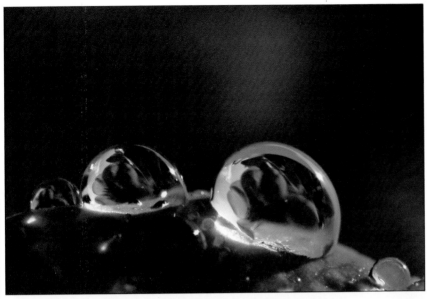

Dewdrops on a wild rose provide a reflection of a complete flower head with a hint of green leaves and blue sky. For this 3 × magnification, the photographer used a bellows unit, shielding the lens with a lens hood as a precaution against flare.

A fungus on a tree stump (below) reveals the delicate texture of its gills in diffuse light from an overcast sky. A 55mm macro lens at an aperture of f/16 provided sufficient depth of field.

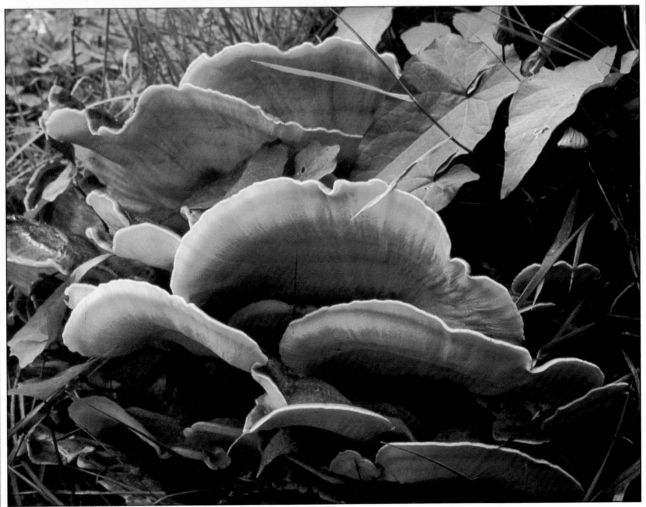

Closing in/3

Flash units are very useful tools for close-up photography, both indoors and outdoors. When available light is dim, flash enables you to set a small aperture to increase depth of field. Moreover, the brief duration of flash freezes motion – invaluable for photographing live subjects such as the butterfly on the opposite page, below.

Small portable units are the best choice for close-ups, as larger units will usually be much too powerful. You may even need to reduce the output by placing a neutral density filter over the flash head. For fill-in lighting, a small reflector of aluminum foil or white cardboard is usually adequate. You can easily soften shadows by directing the flash head onto a piece of white cardboard. Occasionally, you might want to create sharp shadows on a miniature scale; one method is to set up a small mirror (like the kind used by dentists) to reflect a narrow beam of light from a flash unit. For shadowless lighting, you can use ring flash – that is, a flash unit with a circular tube that fits around the lens. A less expensive alternative is to mount ordinary flash units on brackets like those illustrated in the box opposite. Before releasing the shutter, check that the flash will not cast the camera's shadow onto the subject.

Judging the correct exposure when using flash lighting for a close-up can be difficult until you get used to it, because ordinary guide numbers do not apply. The first step is to find a close-up guide number for your unit by making a series of test exposures, as described below. Then, with a simple calculation, you can work out the optimum aperture or flash-to-subject distance for any close-up. With extension tubes or a bellows extension, you must make an additional calculation to allow for the light that is lost as it travels from lens to film. The formulas for both calculations are given below (steps 3 and 4). However, if you have a dedicated flash unit and a camera with a TTL meter that reads directly off the film plane, correct exposure is set automatically.

Exposure calculations

The step-by-step sequence at right describes how to work out the exposure for a close-up taken with a single flash unit. Step 1 explains how to find the guide number of your unit by making an exposure test (using a normal lens without a close-up attachment). Steps 2 to 4 describe how to calculate exposure for a particular subject taken with a bellows, extension tubes or a macro lens.

If you are using two flash units of equal power at an equal distance from the subject, give one stop less exposure than you would with only one unit. Similarly, when using a faster or slower film than the one used for your exposure test, adjust the exposure accordingly.

With a supplementary close-up lens, you do not have to compensate for light loss. Therefore, once you know the close-up guide number for your unit, you can work out the aperture for any flash-subject distance – or vice versa – by applying this simple formula: close-up guide number = aperture × flash-to-subject distance.

1 – Finding the flash guide number

Choose a simple close-up subject and set up the camera with the lens at f/22. Using off-camera flash, make a series of test exposures at various flash-subject distances. After processing, pick the frame that is correctly exposed, then multiply the flash-subject distance by 22 to determine the unit's close-up guide number.

$$m = \frac{v}{w}$$ where m is the magnification, v the width of the frame, and w the width of the field of view.

3 – Calculating the magnification

Work out the magnification by means of the above formula. The value of v will depend entirely on the format of the film you are using and on whether you have composed the picture horizontally or vertically. For example, with 35mm film, v is $1\frac{1}{2}$ inches (36mm) if the picture frame is horizontal, and one inch (24mm) if you have turned the camera sideways for a vertical image.

2 – Measuring the field of view

Set the camera and close-up attachment in front of the subject you want to photograph, and compose the picture. At the subject position, place a small object such as a film pack at each side of the field of view so that it grazes the frame edge when you look through the viewfinder. Then measure the distance between the two objects.

$$e = (m + 1)^2$$ where e is the exposure compensation factor, m the magnification.

4 – Judging the exposure

Calculate the optimum aperture by dividing the flash unit's close-up guide number by the flash-subject distance. Then use the above formula to work out the extra exposure required. This gives you a factor that you must round up or down to 2, 4, 8, or 16, then convert into stops. For example, if the formula yields a factor of 10, allow 8 times more exposure – that is, three extra stops.

Supports for flash units
Various brackets for mounting one or more flash units in different positions around the camera are available for close-up photography. One popular design of bracket is illustrated at right. An alternative approach is to use C-clamps to attach the units to a table edge.

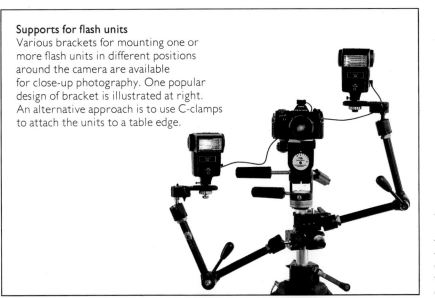

A Jezabel butterfly rests on a leaf. The photographer used a bellows unit to show the subject $\frac{3}{4} \times$ lifesize on 35mm slide film. He illuminated the subject with a small portable flash unit, since there was insufficient available light in the daylight studio where he was working.

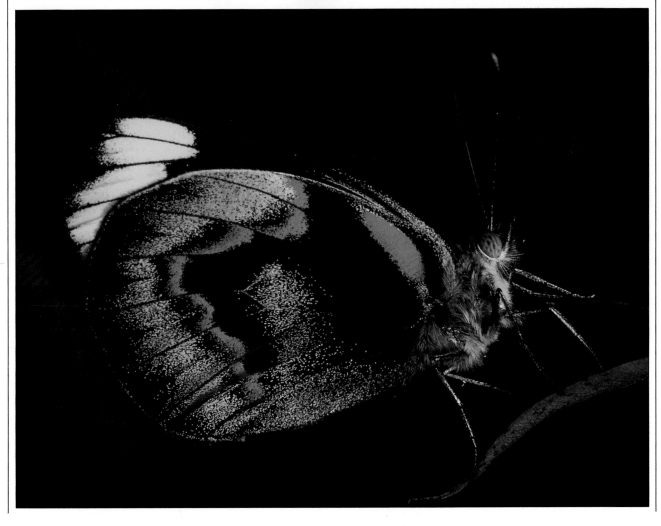

The night sky / I

Photographers who aim their cameras at the night sky may be compelled by scientific curiosity or by the magic and romance of moonlight. Those whose interest is principally astronomical will probably want to use a camera in conjunction with a telescope, as explained on the next two pages. However, for more personal pictures of the night sky, with the moon or stars as a main subject, you can use an SLR camera with just a tripod, a telephoto lens and perhaps a set of teleconverters.

It is relatively easy to take a picture of the moon anchored in a black sky. Such views have little interest in themselves unless the lens has a focal length of at least 1000mm (which gives a subject diameter of just under 10mm on a 35mm slide).

However, moon views are useful for sandwiching into twilit or moonlit landscapes. Exposure is quite straightforward. A full moon requires the same exposure as a sunlit subject on earth; thus, with an ISO 64 color film and a 200mm lens, a setting of 1/125 at f/11 would be a good starting point for a sequence of bracketed exposures. However, a half-moon requires four times this exposure, not twice as much, because the oblique angle at which it receives light from the sun reduces the brightness.

The real challenges begin when you want to include a moonlit scene and the moon above it on a single frame. One of the difficulties is high contrast. A landscape illuminated solely by light from a full moon may be as much as 21 stops dimmer than

Star trails produce a streaked halo around the towers of an observatory in Arizona. The photographer waited for a clear night when the two towers were illuminated by the light of a full moon. He set up his camera on a tripod and made an exposure of 20 minutes to record the star trails and the scene in detail.

the same scene in sunlight. Setting an exposure suffi-cently long to show detail in the landscape will burn out the moon. In addition, the moon will record as an oval or a sausage shape, because of its movement relative to the earth: it takes only about two minutes for the moon to cover the distance of its own diameter. For the picture below, the photo-grapher deliberately exploited this movement to give an interesting shape to the moon's disc.

To retain crisp detail in both the moon and in the moonlit landscape beneath, the best approach is to combine two exposures on one frame. You can either change the camera angle between exposures, as the photographer did for the image below at right, or you can mask different halves of the lens for each exposure. If you have a meter sensitive enough to register moonlight, give one or two full stops less exposure than your meter indicates, otherwise the scene will appear daylit and thus lack atmosphere. Many photographers of moonlit scenes use tungsten-balanced film to create a bluish cast that is closer to the nearly monochrome night vision of the eye.

Like the moon, the stars are in constant motion, and long exposure will show them as trails of light. To minimize these trails, you should allow an expo-sure no longer than the focal length of the lens in millimeters divided by 250. However, by extending the exposure deliberately, you can create arcing patterns that add to the interest of a composition, as in the example opposite.

A silhouetted hillside broods beneath a romantic moon in a view taken with a 300mm lens. Because the moon was close to the horizon, it seemed larger than it would have if higher in the sky. An exposure of almost a minute on Kodachrome 25 film showed the evening sky as a rich blue, but blurred the moon and clouds slightly.

A moonrise over snowfields was recorded as a double exposure. The two images were taken on ISO 64 film, with the lens set at f/6.3 After exposing the moon for just 1/15, the photographer turned the camera around 180° and gave an exposure of seven minutes for the undulating fields.

The night sky/2

Anyone with an interest in astronomy can take pictures of the night sky through a telescope, using a 35mm SLR camera. The camera is normally fitted to the telescope's eyepiece mount by an adapter, as described in the box opposite. To avoid recording stars as streaks, you will also need an "equatorial mount" – a device that rotates the telescope at the same speed as the earth's rotation, but in the opposite direction, following the apparent movement of the stars.

The difficulties of astronomical photography include atmospheric turbulence and the glare from city lights. To diminish these factors, choose a high viewpoint in the countryside. Cold, clear nights are best for views of stars or galaxies, but the moon and planets tend to show up best in hazy skies, which are less turbulent.

For views of the sun, moon and nearby planets, film speeds from ISO 100 to 400 and exposures of up to five seconds or so are suitable, with either color slide or black-and-white film. For more distant phenomena, use films in the ISO 400 to 1000 range. Stars, comets and meteors demand exposures of around several minutes, whereas galaxies need one to two hours. With color slide film, reciprocity failure may seriously detract from the image with

*A **total eclipse** of the sun (left) makes a dramatic image, full of elemental power. The photographer attached an SLR camera to a small reflecting telescope, using an eyepiece projection. He recorded the eclipse on Ektachrome 400 film, then push-processed it by one stop.*

*The **constellation** of the Southern Cross is captured in the photograph at right, taken in Fiji for the purpose of astronomical study. Because the photographer wanted a broad view, he used a 50mm normal lens, attaching the camera to the counterweight of a telescope to take advantage of the telescope's equatorial mount. The exposure was 45 minutes on ISO 200 color slide film, pushed by one stop.*

*The **sequence of moon studies** at right was taken over a period of one month using a 90cm refractor telescope – that is, a telescope that focuses the light with lenses rather than with a mirror. The telescope's equatorial drive kept the image sharp during exposures of up to 10 seconds.*

exposures above 30 minutes; therefore, use either a special astronomical film, such as Kodak's spectroscopic film, or photograph in black-and-white.

Eclipses, such as the one opposite, make fascinating subjects if you can be in the right place at the right time. However, you should never look at the sun directly or through a camera or telescope, or you may blind yourself. The safest approach is to fit a piece of aluminized polyester film over the telescope's objective lens, then project the sun's image onto a piece of white cardboard and photograph that. Exposures of 1/500 or faster will usually give the optimum results.

Photography through a telescope
A 15cm reflecting telescope with an equatorial mount is well suited for astronomical photography with an SLR camera. The adapter for the camera body may either be substituted for the telescope's eyepiece, with the film in the telescope's focal plane, or fitted over the eyepiece for greater magnification of the moon or planets. In the example below at left, there is an extra camera on the telescope's counterweight arm.

A portable telescope like the one below at right is cheaper to buy and obviously easier to transport and set up. In this example, the camera viewfinder is outfitted with a magnifying head to facilitate focusing.

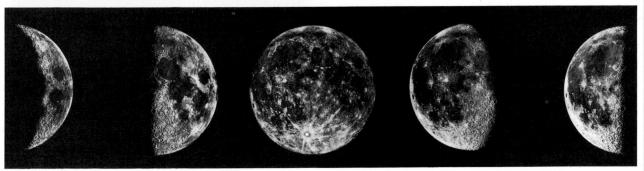

The stage performance /1

Although most stage productions are designed to make a strong visual impact, any photographer wishing to capture stage events faces a number of problems. The first difficulty is gaining access to a performance where photography is allowed. Professional theaters and stage companies usually ban cameras, and almost always ban flash. However, many companies hold a photocall, a dress rehearsal to which press photographers are invited; the panoramic view below was taken at such an event.

Rock concerts offer more possibilities to the amateur. At most, you are relatively free to move about, and cameras are banned only from the stage area itself. Even more accessible are amateur theater, music and dance groups, which offer good training in the twin problems of stage photography: restricted viewpoint and low lighting.

If you can, check out the theater beforehand to find the best viewpoint. Unless the seats are steeply banked, or the stage is very shallow, avoid the first few rows of the auditorium. A pillar or a rail can be helpful for steadying yourself or your camera.

Wielding giant scissors, a mime artist performs in a show based on the Punch and Judy story. The photographer closed in from the middle of the orchestra seats with an 80-200mm zoom lens. He pushed the tungsten-balanced Ektachrome 160 film by three stops.

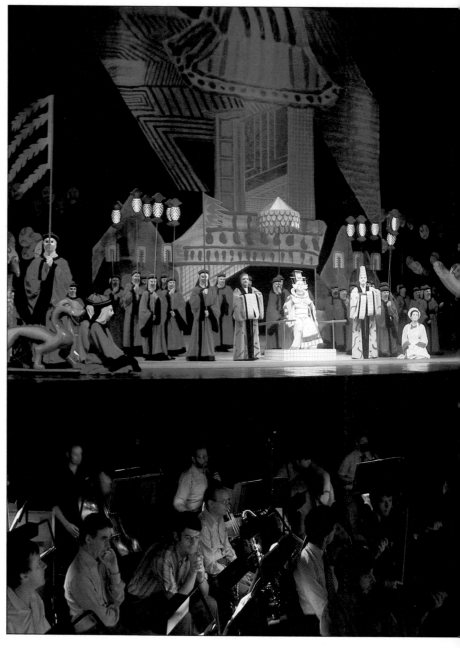

Most photographers use fast tungsten-balanced slide film and push it by one or two stops, since the light is usually insufficient, even with the lens at its widest aperture. For close-ups of individual performers, such as the views below at right and on the opposite page at far left, a medium telephoto or a zoom lens is useful; however, unless your lens has a maximum aperture of f/2.8 or wider, you may need to push the film by as much as three stops. For an impression of the overall scene, use a wide-angle lens from an off-center position.

Clutching his microphone, English rock singer Ian Dury (above) is caught in close-up with a 105mm lens used on a handheld camera from a position in the audience. The Ektachrome 160 film was pushed two stops to register an acceptable image at a shutter speed of 1/125.

Bathed in blue light, a scene from Stravinsky's opera The Nightingale *runs through its final dress rehearsal during a photocall at London's Royal Opera House. The photographer was interested in both the atmosphere of the event and in the set (designed by artist David Hockney), so he rented a panoramic camera to record the full width of the theater. Pushing Ektachrome 160 film by two stops exaggerated the intensity of the lighting on the stage and in the orchestra pit.*

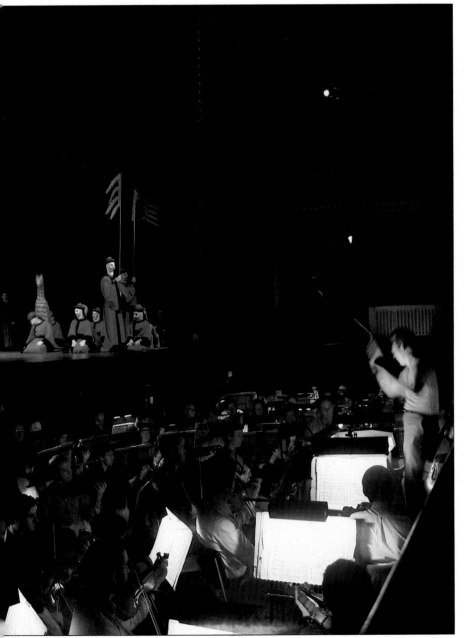

The stage performance /2

To capture dance, swordfighting or other kinds of theatrical movement on film, there are two creative options: freezing movement in order to catch a peak of action, or blurring movement, wholly or partially, by a slow shutter speed. Because the first of these techniques usually requires pushing the film to allow a setting of 1/125 or 1/250, you will rarely be able to combine both approaches on one film. However, the photographer of the image at right resolved the dilemma by using a fast shutter speed with a multi-image filter to convey motion.

To plan your strategy, it helps to see a performance beforehand, or at least study the publicity photographs. Dynamic leaps look good when frozen, but you need to know when to expect them. Only rarely will you be allowed to halt movement by flash, as in the picture on the opposite page. Dancers in swirling costumes usually call for blurred images; but to achieve this you may need to use one of the camera-steadying techniques described opposite.

Graceful choreography
(below) is conveyed by a
one-second exposure. The
photographer steadied his
camera on a monopod.

The energy of a leap
(right) in a dance rehearsal
is conveyed by a multi-image
filter. The photographer used
a 105mm lens set at 1/250.

Simple camera supports

Tripods are banned in most theaters and in any case may be too bulky. A shoulder stock (near right) is a good substitute, permitting speeds down to 1/15 without camera shake. A monopod (far right) will allow speeds down to 1/8, but some theaters may treat this as a form of tripod. It is wise to ask beforehand whether you may use a camera support, even at rehearsals.

A mime artist gestures toward the camera in an unusual view looking out at the auditorium, taken after a performance at Venice's Goldoni Theater by pre-arrangement with the management. A flash unit arrested the action.

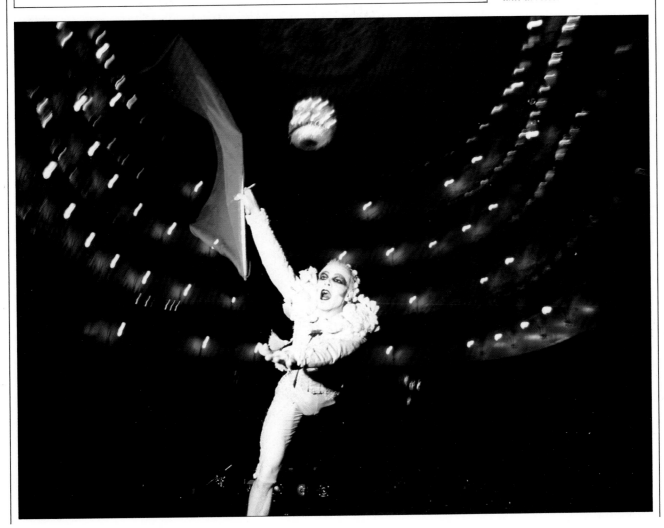

The stage performance/3

Stage lighting during just one performance may range from an overall glow to a kaleidoscope of colors to a single spotlight. Judging exposures in rapidly changing or high-contrast lighting conditions requires skill and experience. Exposure meters may prove unreliable, even when the lighting is stable, but they are useful for indicating a setting to bracket around. You can save vital moments by using your camera in the automatic mode, and bracketing by adjusting the exposure-compensation dial. A meter display of the needle type may be difficult to see in

dim light; a viewfinder with an LED meter display is much easier to read. But with experience you may be able to dispense with meter readings and concentrate on timing and framing.

At a photocall, the lighting may be brighter than that for a public performance, and there is more time for careful metering. For the scene on the opposite page at left, the lighting was kept constant for photographers, making possible an accurate reading with a spot meter. However, photocalls often lack the atmosphere of a real performance.

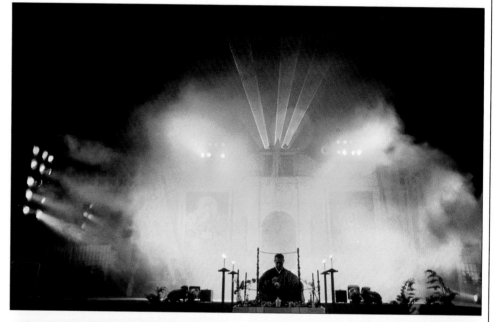

A Buddhist monk performs a religious ceremony on stage at an outdoor concert by Japanese percussionist Stomu Yamashta. From a central position in the audience, the photographer used tungsten-balanced ISO 160 film with a 50mm lens, relying upon his experience to judge the exposure at 1/30 at f/2.

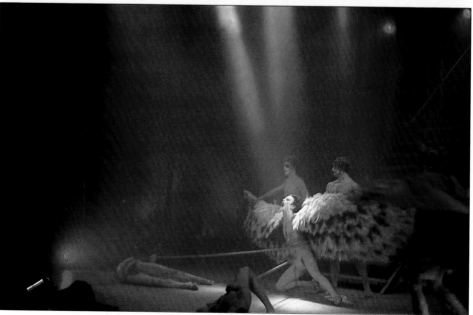

Spotlights beam down on a winged actor in a performance of Salome. To ensure maximum detail in both shadows and highlights, the photographer took an exposure reading for the mid-tones. Because the overall lighting was relatively bright, he was able to freeze movement with a shutter speed of 1/250.

The visual excitement of a rock concert or musical depends on rapid color changes and moving beams of light. These effects can look good even when frozen on film, but for less lavishly staged performances, the lighting may look dull. One solution is to use a starburst or diffraction filter, as in the picture below at right. Colored gels over stage lights affect color temperature, but it is unwise to attempt corrective filtration: even wildly unrealistic flesh tones seldom look disturbing on stage and can intensify the theatrical mood of an image.

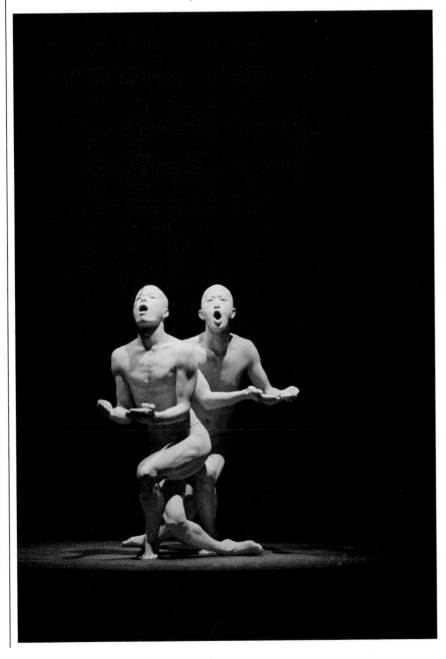

A comedian entertains his audience at a nightclub (above). From his position on one side of the stage, the photographer used a 35 mm lens, attaching a starburst filter to add color to the upper area of the image. High-speed daylight-balanced film increased the feeling of warmth and intimacy common in such clubs.

Two Japanese dancers are frozen like marble statues under a spotlight at a photocall. The photographer took a spot meter reading and underexposed by one stop, preventing the bright highlights on the figures from burning out and emphasizing their sculptural quality by deepening the shadows.

The calculated illusion/1

One of the aims of a professional still-life photographer is to impart such three-dimensional immediacy to an image that the viewer almost feels that he can reach out and touch the objects within the picture frame. This demands grain-free transparencies with brilliant color rendition. Many studio photographers, including the ones represented here, use a large-format camera to achieve such critical results, although others obtain almost comparable quality with a 35mm SLR camera loaded with a slow slide film like Kodachrome 25 film.

Another goal is to idealize the subject, which means that every blemish must be removed. For example, the corkscrew still-life at right required no sophisticated lighting or camera techniques, but was a difficult subject because the shiny metal corkscrew and the surface it rested on would have shown up fingermarks glaringly. You can remove obstinate fingermarks from most metal surfaces with acetone or rubbing alcohol. Here, however, the photographer ensured that this emergency never arose by handling the corkscrew with a soft cloth and taking great pains not to touch the plastic base.

Outsiders sometimes regard the still-life studio as a problem-free environment. However, one mark of the professional is that he allows time to think about the problems inherent in the idea for a shot, and work out ways to solve them. If there is no instant solution, he must often resign himself to laborious approaches with which an amateur would soon lose patience. For example, in the study of guitars on the opposite page, above, the main difficulty was dust, which the raking lighting revealed with painful clarity. The only solution was to dust the surfaces frequently and thoroughly with a cloth. This task, added to those of adjusting lighting and composition and making a sequence of test photographs on instant film, stretched the total time required for the session to 10 hours.

A more unusual problem is exemplified by the still-life on the opposite page, below. The photographer wanted to include a drip on the verge of falling from the melting ice cube, which ruled out using an acrylic ice cube of the type often used in food studios. He knew that the studio lights would rapidly melt real ice, so that the cube would shrink and slip out of the tongs, which were held in place in a retort stand – a laboratory stand with a clamp mounted on it. The solution was simple but effective: a rubber band pulled the tongs together as the cube melted and so maintained a firm grip. The photographer also found that the cherry began to color the water if left in the glass for more than a few minutes; so he had to replace the water and cherry frequently before taking this final picture.

A corkscrew surrounded by crushed ice forms a double image. Before setting up the composition, the photographer polished the plastic base with an antistatic cloth; an ordinary cloth would have created a dust-attracting charge. An overhead window light provided diffused lighting, while two pieces of black cardboard, one on either side of the subject, edged the corkscrew with black reflections that defined its shape.

Guitars *(above) nestle against each other in a still-life created for a record cover. The guitars rested on sandbags, their necks supported by an overhead wire. The angles of the guitars and of the two spotlights that illuminated them (diagrammed above at left) were critical: the spotlights had to define the edges of the instruments, highlight the strings and show enough overall detail without spoiling the subdued mood.*

A droplet *from a melting ice cube is poised to fall into a glass of water. To create the tiny bubbles, the photographer added a little wetting agent. The setup, diagrammed above, included a window light, black cardboard and a plastic base. The photographer took care to define the sides and rim of the glass against the black background and to silhouette the cherry stem against a highlight.*

The calculated illusion/2

Food photographers face a triple challenge: their images must make the food look as appetizing as possible, evoke a mood or context, and have a strong esthetic appeal as still-lifes. All three pictures shown here demonstrate how a meticulous approach to composition, background and lighting plays a vital part in meeting these criteria.

Obtaining the right ingredients can itself be a problem. For compositions based on perishable foods, such as the one opposite, it is essential to buy the best-formed, freshest-looking specimens. Professionals sometimes have to show out-of-season fruit or vegetables: produce that has been deep-frozen may be acceptable, though it is preferable to ask a supplier to obtain fresh produce from abroad. But it may be more convenient to use a lookalike substitute; you can sometimes disguise a difference in scale by careful composition.

Some photographers draw upon special techniques to control the appearance of foods. Glycerin brushed onto fresh fruit will give an effect of succulence, as in the picture below. And a wisp of smoke directed through a hidden straw can help to restore an oven fresh appearance to hot dishes. However, laws protecting consumers limit "cheating" in advertising photos, and it is often necessary to reveal the inherent qualities of food rather than seek to improve upon them.

Lighting should generally reveal the food's texture. A standard technique is to use broadly diffused light angled down onto the subject from above the camera, as in the image below. However, lighting must also suit the intended mood of a picture. This was a primary concern in both the images on the opposite page, which exploit the qualities of diffused flash combined with daylight.

Chopsticks and a bamboo mat indicate the origin of the Chinese-style fruit salad at right. The photographer used a broad, diffused flash above the subject, angling it carefully downward to create a dark background that shows off the colors of the fruit to best effect.

Fresh produce (left), *photographed as a cover illustration for a cook book, benefits from a simple setting of plain white tableware, which emphasizes the carefully contrived arrangement of the food's colors and textures. Diffused flash, supplemented by daylight from a window, provided the lighting, with a reflector to fill in unwanted shadows.*

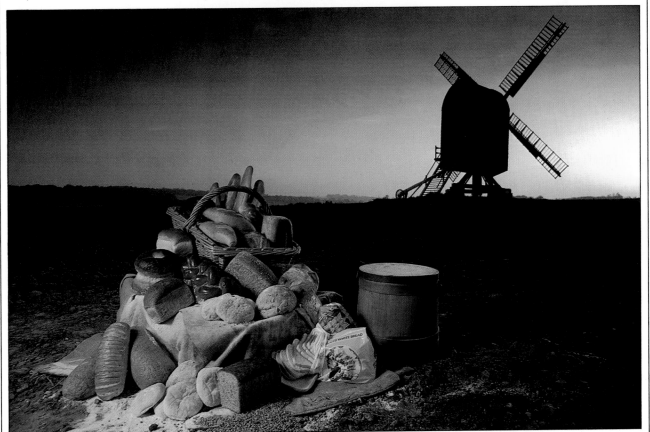

A mound of loaves, with two pre-sliced factory loaves placed alongside, makes a statement in favor of old-style baking. The windmill, the mellow evening light (supplemented by diffused flash) and the "spilled" flour make a vital contribution to the picture's atmosphere.

The calculated illusion/3

Photographic fantasies such as the ones shown here have two components: the idea and the technique. The idea must be inventive yet simple, and the technique disguised. The viewer will be vaguely aware of trickery, but should be mystified or at least uncertain as to precisely how the photographer obtained the picture.

There are several approaches to creating a convincing illusion. One is to take far more time and care over the preparations for a picture than the viewer is likely to guess. For example, the sword-fighting scene on the opposite page, below, uses the standard technique of a double exposure with the lens partially masked. However, the photographer has made the technique less obvious by using two masks, one of them L-shaped, so that the two parts of the image interlock. The composition depended

on the swordsman's leaping high enough to clear the mask covering the paving stones.

Another approach is to exploit a method that is basically simple, but difficult to detect because it runs counter to the viewer's deepest assumptions. In the picture opposite, our first thought is to look for hidden supports. But in fact the figure bounced from a trampoline, the simulated bed and doorway are at right angles to their customary position and the resulting picture has been turned from a vertical to a horizontal format.

The picture below gains in impact from a more subtle change of orientation. By tilting the camera very slightly, the photographer has not only created a sense of movement, but has also disguised the trick of rotating the figure on a turntable to create the hoops of light.

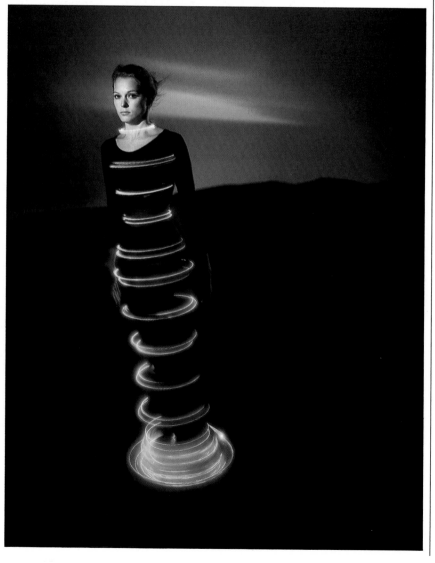

Enclosed in swirls of light, a woman appears to glide by supernatural means through a twilit landscape. For this elaborate studio picture, the photographer stood the model on a specially built turntable with Christmas tree lights fastened to her back, as diagrammed above. He set up a large-format camera at a slight angle, with the rear lens panel tilted so that the woman would also seem to lean forward, and made an exposure using studio flash units. Then, in darkness, he went over to the turntable and spun it so that the electric lights created circular trails around the woman as she turned.

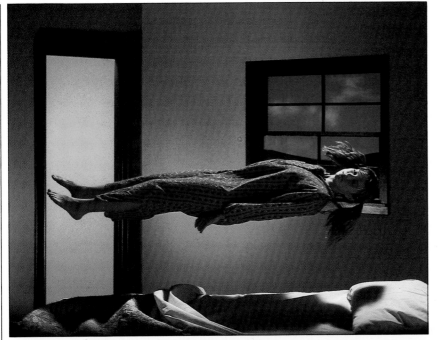

A levitation scene owes its convincing illusion to the unexpected use of a trampoline in a picture that has been turned around 90°. The door was a horizontal panel of colored plastic illuminated from behind, while the bed was a block of foam wrapped in sheets and supported by a wood frame.

A swordsman fights his double (below). The photographer cut two interlocking masks from black cardboard and used them to cover opposite halves of the lens during two exposures on one frame. The slightest camera movement would have caused an imperfect alignment of the two exposures: to prevent this, the tripod-mounted camera was weighted down with sandbags.

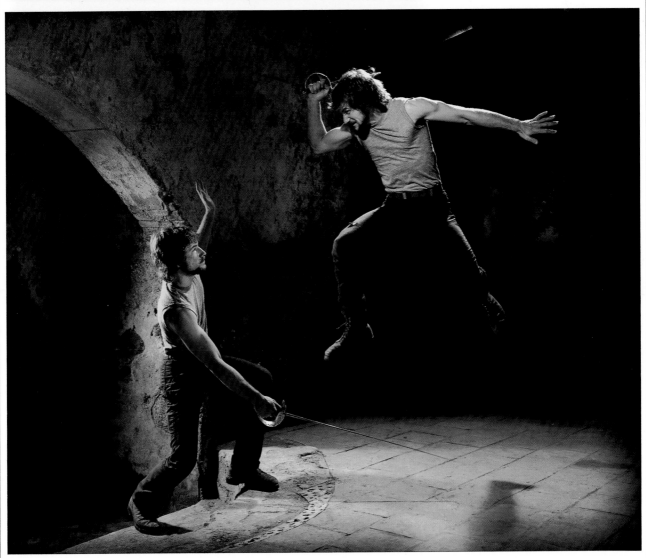

The remote-control camera/1

To achieve an image that is out of the ordinary, photographers may sometimes wish to use a viewpoint that is inaccessible or dangerous at the best moment for pressing the shutter release. In such situations, the only feasible approach is to set up the camera beforehand, preset the focus and the exposure controls (usually in the automatic mode), and then trigger the shutter release at the right time by remote control. The pictures on these two pages show the value of this method for obtaining images from a moving craft or vehicle: all three images have a strong sense of immediacy. The remote-control approach is particularly effective for self-portraits taken by the pilot or driver.

There are various remote-control techniques, each requiring an eye for improvisation. A pneumatic cable release operated by squeezing a rubber bulb at the end of a tube, which screws into the shutter release at the other end, is effective up to distances of about 30 feet (9 meters). Beyond that the simplest and most reliable control is an electric cable combined with a motordrive. Two wires attached to contacts on the motordrive activate continuous picture-taking when the photographer touches the ends of the wires together, usually by means of a switch.

Sometimes it is impossible to rig up a cable between the photographer and the camera. In such cases, an infrared trigger may be the answer. One popular type is marketed by Nikon under the name of Modulite. Many photographers use this for all their remote-control work in order to avoid inconveniently trailing cables. A hand unit emits a pulse which is picked up by a receiver on the camera's hotshoe; this in turn sets off the motordrive, or takes a single frame, depending on how you operate the controls. Infrared releases are effective up to about 180 feet (56 meters).

Radio-control units offer yet another method. They have the advantage of allowing a considerable operating distance without requiring a direct sightline to the camera. However, in some countries radio frequencies are so crowded that other transmitters may operate your camera inadvertently.

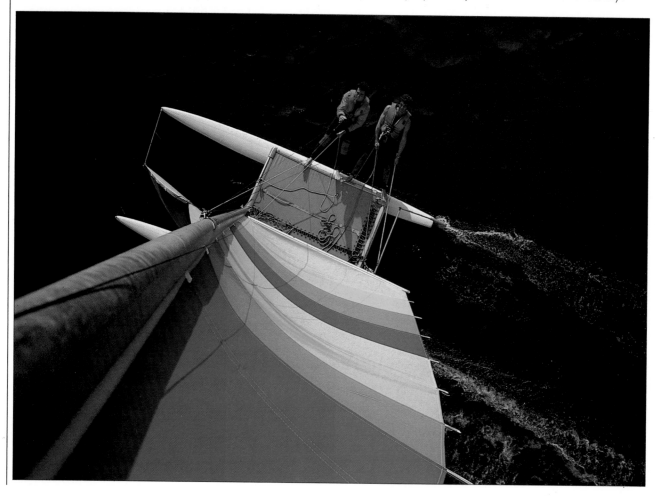

Attaching the camera

Setting up the camera securely can be the most difficult part of remote-control photography. Gaffer tape and G-clamps are very useful for improvising support, but many photographers who use remote control regularly have special brackets made, like the one shown above.

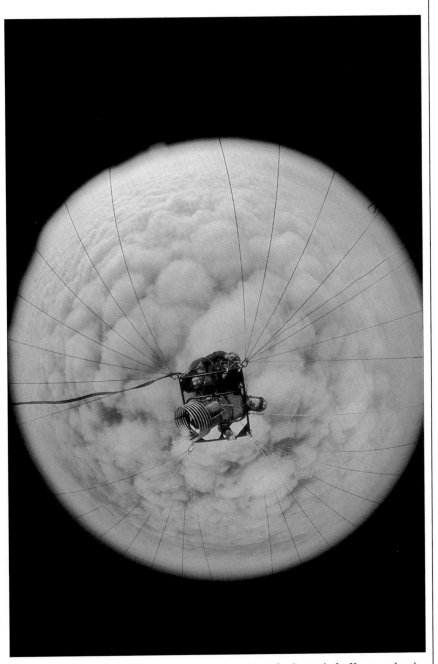

A hurtling bobsled is caught in a fisheye view by a camera mounted on its nose and operated with an electric cable by a crew member.

A dizzying view of the crew of a catamaran (left) was obtained by hoisting a prefocused camera to the top of the mast and triggering the shutter from land by a radio transmitter.

A view of a hot-air balloon, taken by remote control from a camera suspended in the mouth of the balloon's vast envelope, makes a highly original image, heightened in impact by the use of a 16mm fisheye lens. Although the photographer normally uses an infrared trigger for this kind of picture, in this case he experimented with an electric cable, which can just be seen as a white line on the right side of the frame.

The remote-control camera/2

Self-triggering remote-control systems allow photographers to choose timid wildlife – creatures that would instinctively flee the scene if they sensed a human presence – as subjects for close-ups. And by combining these systems with flash, you can produce fascinating studies of "frozen" animal movement, like those shown on these two pages. Photographers who use such setups can remove themselves entirely from the scene, although many prefer to keep an eye on their equipment from the secrecy of a nearby blind. The photographer of the bird pictures here often places the camera itself in a blind so that he can control exposure settings as the light changes.

When leaving a self-triggering system outdoors for any length of time, it is essential to protect it from dew and rain with plastic bags.

To set up a self-triggering remote-control system requires a little ingenuity and a basic knowledge of electronics, as the two smaller pictures here suggest, but is not overly difficult. You will need an infrared transmitter to produce a continuous light beam that will neither register on film nor disturb the subject, a securely mounted camera with a solenoid or motordrive to release the shutter, two or more flash units and a battery to supply the power. Breaking the beam disrupts the electrical

A house martin chick opens its mouth expectantly while watching its parent approaching the nest. For this picture, the photographer had no need to build a blind or camouflage his apparatus, since house martins are accustomed to living in close proximity to human beings. Thanks to this lack of shyness and the nest's accessible position under the eaves of a bungalow, the photographer obtained a successful image within only two days. He placed his transmitter on the black tripod under the birds' nest, and set up the receiver near the eaves (on the left in the smaller picture here), on the far side of the house martin's flight path. A pair of flash units were mounted on tripods, one at either side of the bird's route. A wet-cell battery supplied power for all the units. Because the parent bird was frequently on the scene, the photographer was able to catch many successful views of it.

circuit, releasing the shutter and simultaneously firing the flash.

You can photograph birds most easily when they are approaching or leaving their nests. With careful observation, you can anticipate their flight paths and plan where to place your equipment. Set up the components gradually, taking care not to disturb the bird, or it may abandon its nest and young altogether. Prefocus the camera on the bird's flight path, and frame the picture to allow for a fractional delay between the breaking of the beam and the release of the shutter. The sensitivity of the unit should be adjusted to the size and position of the subject: for

example, when photographing a small bird you must carefully prepare the unit so that it is not triggered off by large insects.

A slave unit offers a convenient way of synchronizing two flash units. However, a more reliable method is to use electrical leads – one from each unit, joined at a junction box from which a third lead stretches to the camera's X socket. A self-triggered camera used with flash works best if it has a blade type shutter, which synchronizes with the flash at speeds up to 1/500. With focal plane shutters, the flash synchronization speed is 1/60 or 1/125 – too slow if you are photographing in bright sunlight.

A kestrel arrives at its tree-hole nest bearing a fledgling starling to feed its young. To observe the creature initially and work out where to place his apparatus, the photographer erected a blind 20 feet off the ground, level with the nest. A transmitter below the tree-hole sent a light beam to a receiver directly above it. The camera, fitted with a medium telephoto lens, was mounted on a tripod in the blind. A pole between the blind and the nest held the flash unit in place.

The photographer set up this equipment gradually over a period of three weeks to avoid disturbing the kestrel. He then spent 10 uncomfortable days trying to photograph the bird, which visited the nest only once or twice a day and kept altering its route of entry. As a result of this experience, the photographer decided to use a motordrive for future remote-control work with shy subjects.

Photography in museums

Photographing works of art in a museum demands a precise and controlled technique combined with a decisive choice of the qualities you want to convey. It also demands considerable preparation, including liaison with the museum authorities, both to obtain permission if necessary and to arrange a time when the public will not interrupt photography.

Slow film is essential for capturing surface details or textures. Many museum photographers use a view camera with a range of lens movements that give fine control over focusing and perspective. But with care you can achieve good results with an ordinary 35mm SLR on a tripod. Using a 105 or 135mm lens, you can set the camera well back from the subject, allowing plenty of room for lights or reflectors; this is useful with small artifacts.

A long lens also helps to isolate the subject from its background, which can be a major concern with sculptures and historic relics. Another way to handle this is with a background sheet of black velvet, as in the picture below. Sometimes you can use shadows effectively, as in the image opposite; or close in, as shown below at left.

Illumination should be as natural looking as possible. If available light is insufficient, use diffused flash, which allows a small aperture without the problems of reciprocity failure that can accompany long exposures.

A transparent sculpture in the Museum of Modern Art in Mexico City revealed its distinctive qualities better in a close-up taken with a 100mm lens (above) than when photographed in its surroundings with a 50mm lens (top).

The golden funeral mask of Tutankhamun looks dramatic and sumptuous in a classic profile view. A large-format camera, used with diffused flash, produced pin-sharp image quality. A black sheet behind the camera and black tape covering all shiny surfaces prevented reflections from the side of the glass case containing the mask.

An ancient statue benefits from
dramatic but simple lighting from a
diffused flash unit, mounted inside a
silvered umbrella and placed to the left
of the subject. The photographer closed
in with a 135mm lens.

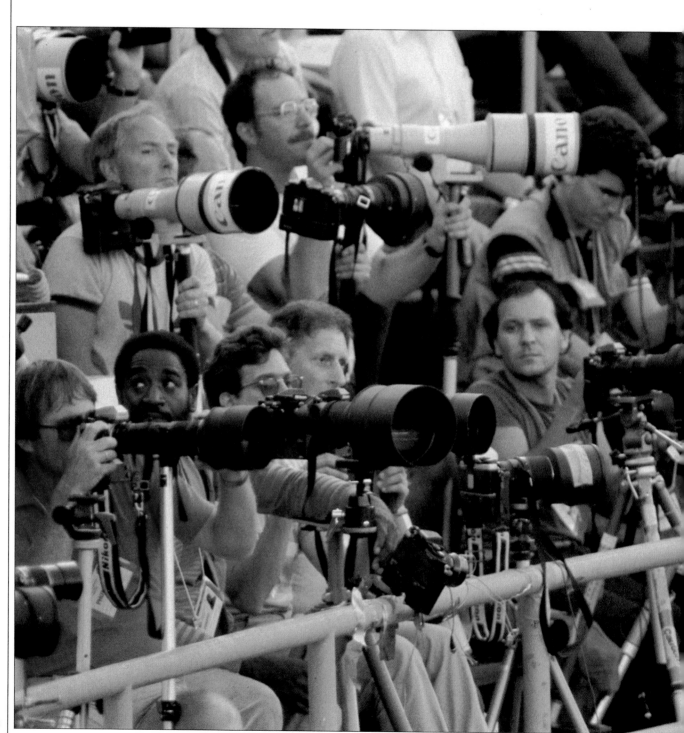

THE SPECIAL ASSIGNMENT

Professional photographers on assignment have a wide freedom of choice with regard to equipment, film type, composition and creative techniques. However, there is one option that is not available to them, and that is to return home without stunning pictures that will earn their place in a magazine or book. To guarantee a high success rate, the chief requirements are efficient, high-quality equipment; detailed knowledge of the subject; thorough preparation for the task; and an ability to cope with unexpected obstacles by improvising solutions if necessary and drawing upon resources available on the spot.

Some of the problems that may challenge a professional are of a kind that seldom inconvenience the casual amateur. For example, a photographer covering an unrepeatable event such as a bicycle race or the launching of a ship may be hampered by a crowd of other professionals competing for the same images, as the picture at left dramatically illustrates. And with more general assignments there is always a time limit.

This section looks at six different assignments or projects, each of a complex nature, and explains how each photographer solved the problems inherent in the task, as well as the unpredictable difficulties that chance brought his way. Some of the projects required special privileges of access, whereas others would have been available to any amateur. But the unifying theme throughout is an adaptable, meticulous and determined approach that all photographers must imitate if they are to tackle difficult photographic situations successfully.

Press photographers jostle elbow to elbow at an athletics championship in Helsinki, Finland.

Food on location

The London-based photographer Roger Phillips combined botany, cookery and photography in a two-year project that won him the André Simon award for the best British cookbook of 1983. His aim was to produce, as both author and photographer, a cookbook based on ingredients that grow wild in the British and Irish countryside. Because Phillips wanted to show both plants and finished dishes in their natural habitat, the project involved detailed planning, a lot of traveling, and many hours of cooking on a camping stove, wood fire or borrowed oven. The distribution of the rarer plants also determined where the more common species could be photographed to reduce traveling to a minimum.

Phillips used a 35mm SLR camera with a range of lenses and photographed entirely by available light.

A lightweight tripod was essential because many of the locations were at some distance from the road. One problem was to choose a film that would cope with unpredictable weather, yet produce images that would stand reproduction at sizes up to 10 inches in the large-format cookbook. The choice was Ektachrome 64: pushing this film one stop allowed apertures down to f/16 combined with shutter speeds fast enough to arrest the swaying of plants in the wind. As a bonus, pushing the film had the effect of increasing contrast.

Phillips often had to improvise. For example, he chose props like the wooden chair in the picture below at left from whatever was available nearby. And for the image opposite, he paid a boy to deter people from walking down the steps.

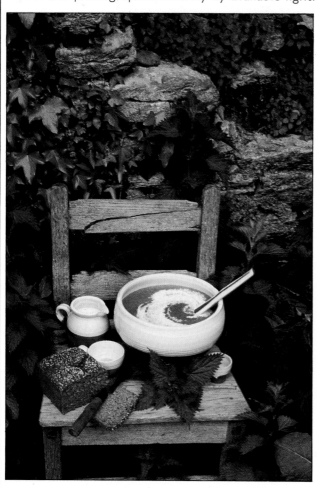

Nettles form an appropriate frame for a bowl of nettle soup, photographed among abbey ruins in Ireland. Wearing gloves that he carried in his car, Phillips cleared away nettles from the foreground before taking the picture.

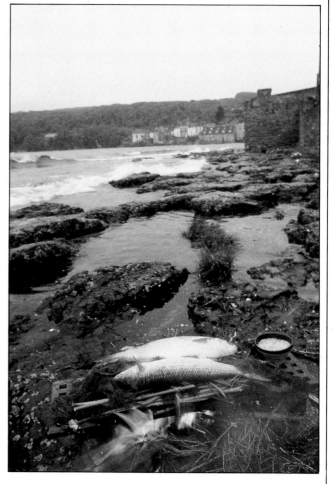

A brace of fish on a bed of fennel cook over a wood fire on a Cornish beach in a view taken with a 35mm lens. Phillips set up the picture and managed to expose a complete roll of film before the incoming tide swamped his subject.

A quiche made from sea beet fills
the foreground in a dramatic view taken
with a 28mm lens. Phillips chose this
architectural location as a counterweight
to the open rural settings that seemed likely
to dominate his book.

Olympic skiing

Leo Mason was one of many top sports photographers covering the Winter Olympics at Lake Placid, New York, in February 1980. Despite the intense rivalry, he was able to sell his pictures all over the world. In part, he owed this success to an ability to work efficiently and creatively in tough weather conditions and to find imaginative solutions to the problems of restricted viewpoint.

Mason knew from experience that he would have to spend a lot of time waiting for the action. With strong winds and temperatures dropping below −30°F (−34°C), a warm parka was essential. But to avoid fumbling with camera controls and missing an unrepeatable picture, Mason wore silk gloves, which barely kept his hands warm. There was thus a real risk of dropping the camera. If the camera had fallen into the snow, it would have been all but impossible to brush the ice off. To prevent this from happening, Mason used his neckstrap at all times.

Mason's coverage of the ski events shows the versatility of his approach. For maximum mobility, he was equipped with skis, and therefore carried the minimum of photographic equipment, stowed in a skier's backpack. Tripods were useless on the steep, slippery slopes, so he used a monopod, even with extra-long lenses.

Competition for viewpoints was fierce. For the ski jump there were four basic positions, diagrammed at right. Most popular were the viewpoints just under the lip of the jump, either 15 to 20 yards down the hill, or, for a spectacular overhead view like the one on the opposite page, below, on the small ledge used by the takeoff judges. The third position was a precarious perch halfway down the slope, where Mason captured the competitors as they flew toward him, or with perfect timing panned them as they passed. Last, there was a position at the bottom of the slope; from here, by prefocusing with a 1200mm lens, he could catch the skiers as they took off.

There was a wider range of viewpoints for the downhill events, but great skill was required to seize exciting, uncluttered images like the one below. Mason usually looked for a gate at the end of a fast, straight section where skiers would make a tight turn, and where there was a chance of a mistake.

Ski jump viewpoints

Judges' ledge

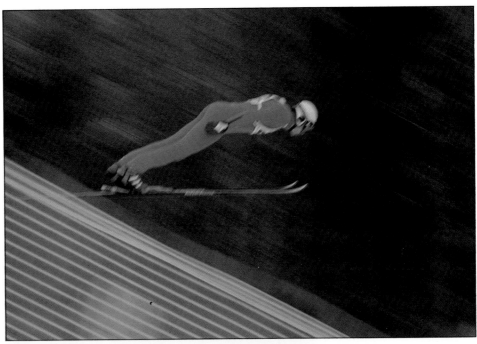

A panned view (above)
freezes a ski jumper's
movements as he glides
through the air, but blurs a
yellow fence behind him to
give an impression of speed.
Using a 180mm lens, which
gave little latitude for
framing, Mason took the
picture from just under the
lip of the ramp. Because
there was no snow in the
background to mislead the
meter, an automatic exposure
yielded an excellent result.

A ski jumper in blue
looks as if he is about to
land among the crowd in a
picture taken from the takeoff
judges' ledge. Because this
viewpoint was greatly coveted
by photographers, Mason had
to get into position several
hours before the event was due
to start.

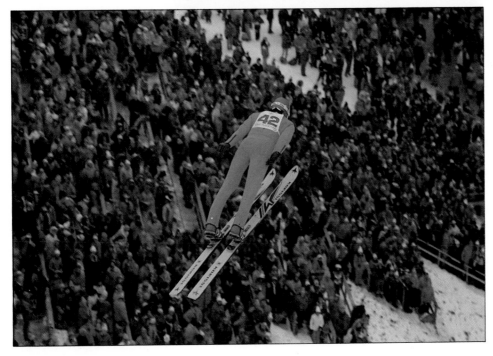

A spray of snow (left)
neatly conceals spectators
in a dynamic close-up of a
downhill skier taken with a
300mm lens. An 81B filter
prevented the heavily overcast
sky from tinting the white of
the snow with a blue cast.

Insects in flight

In the mid-1960s, early in his illustrious career as a natural-history photographer, Stephen Dalton received a commission to photograph the life cycle of the honeybee. However, he discovered that none of the equipment available was capable of freezing the motion of the insect's wing beats. Some years later, an engineer developed for him a high-speed flash unit that emitted bursts of light as brief as 1/25,000 second. A rapid-action shutter, designed for use with the flash unit and with a photoelectric self-triggering remote-control system, reduced the time lag between the release and activation of the shutter from the usual 1/10 second to an impressive 1/1,000. But even with such sophisticated equipment, there were still immense difficulties involved in photographing insects in flight, a challenge that continued to absorb Dalton for many years.

Insects fly erratically, with sudden shifts of direction. Without some way of channeling its move-

ments, the chances that an insect will cross the light beam at the right place are infinitesimally slender. Therefore, to help coax his subjects into the camera's field of view, Dalton devised the portable light tunnel shown on the opposite page. Yet even this did not offer a complete solution to one of the overwhelming problems of insect photography: limited depth of field at high magnifications. If the subject were, for example, a ladybug photographed a quarter life-size at an aperture setting of f/16, the depth of field would be just adequate to take in the insect's width. For a completely sharp image, Dalton had to anticipate exactly which part of the insect's anatomy would break the beam, fine-tuning the sensing system if necessary to get the result he wanted. For example, he could adjust the sensor so that the fast-moving wings of an insect, but not its relatively slow-moving body, would trigger the camera and flash units.

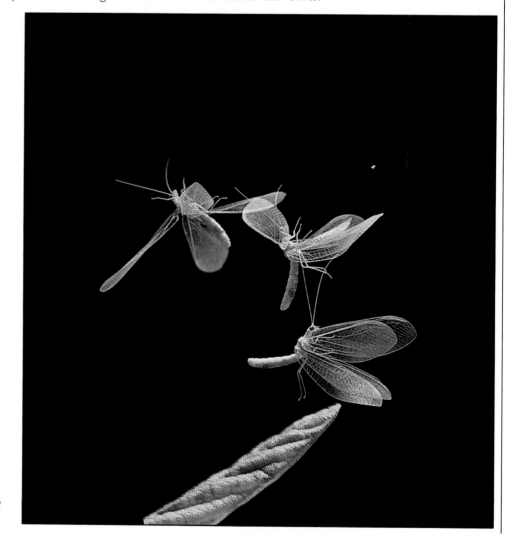

A lacewing shows off its vertical takeoff skills in a series of remote-control exposures on one frame. To make this multiple image, Dalton used three separate flash units with a delay circuit that controlled their timing. He spent three weeks photographing lacewings and used up 900 frames.

The flight tunnel

The setup shown at right, with its associated electronics, was developed by Stephen Dalton. The core of the system is the flight tunnel, which works on the principle that an insect trapped in the tunnel will fly toward the exit, attracted by the light. A pencil-thin light beam directed across the exit aligns with a photo-electric cell. An insect breaking this beam, at a point on which the camera is prefocused, disrupts a circuit and triggers the camera and flash units.

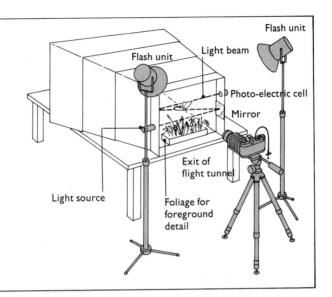

Flash unit

Flash unit

Light beam

Photo-electric cell

Mirror

Light source

Exit of flight tunnel

Foliage for foreground detail

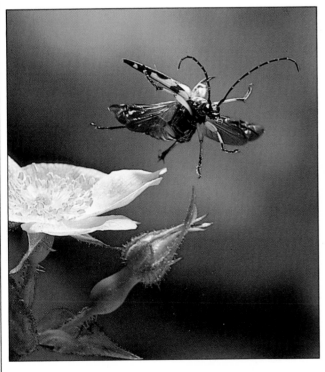

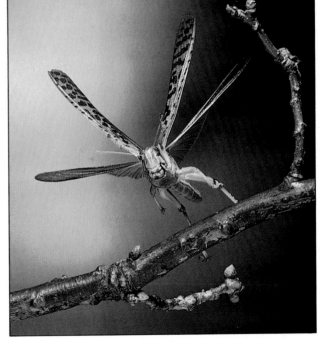

A ladybug scatters pollen as it takes off from a flowerhead, wing cases akimbo. As in the image of the desert locust, Dalton placed natural props in the flight tunnel to give an impression of the subject's habitat, as well as to coax the insect into demonstrating its characteristic maneuvers.

A desert locust demonstrates its trait of leaping into the air with a massive thrust of its hind legs before using its wings. Dalton correctly anticipated that the locust would need the full length of the flight tunnel to pick up air speed before flying toward the light at the tunnel's exit.

Hotel in the Tropics

When architectural photographer Richard Bryant was commissioned by a leading architectural magazine to photograph the beautiful Triton Hotel at Ahungalla on the southwest coast of Sri Lanka, his first problem was how to limit the weight of his equipment. Normally, Bryant uses a 4 × 5-inch view camera for architectural assignments. However, he decided that it would be too bulky for such a long trip, and that storing and changing sheet film in February, Sri Lanka's hottest and most humid month, would be extremely troublesome. Instead, he took along a Linhof medium-format rollfilm camera, which offers a compromise between the portability and convenience of a 35mm camera and the image quality of a view camera. Moreover, the Linhof camera's range of lens movements makes it possible to adjust the perspective to ensure that vertical lines in an architectural view do not appear to converge even when the camera is tilted. Bryant packed his film and equipment with plenty of moisture-absorbing silica gel, and after checking in at the Triton immediately arranged to borrow space in a refrigerator to store unexposed and exposed film.

The intense sunlight caused high contrast, which called for careful judgments about exposure. For example, in the picture below, Bryant decided to sacrifice some foreground detail for an accurate rendering of the sea in the background. To a great extent, these exposure decisions depended upon a sensitive interpretation of the esthetics of the architecture.

One way to sidestep the difficulty of high contrast

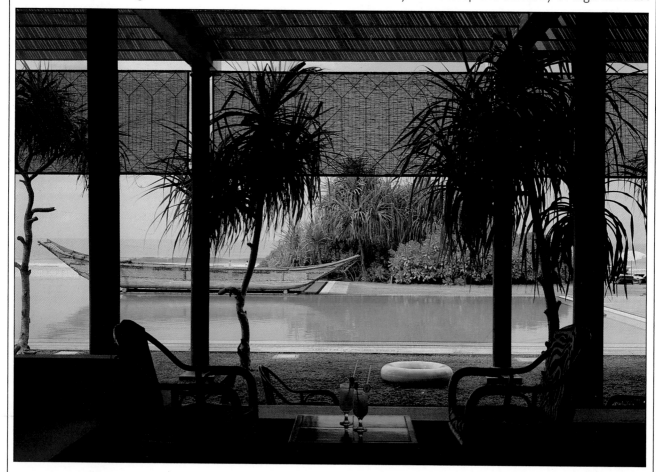

Pillars and palm trees *frame a view of a swimming pool and the ocean beyond. To convey the coolness of the interior and ensure that the faint horizon was visible in the image, the photographer based his exposure on a meter reading of the sunlit areas.*

and also bring out the hotel's character was to photograph at twilight. However, since night falls suddenly in equatorial regions, Bryant had to act quickly to obtain a picture like the one below, before the sky turned entirely black. By using tungsten-balanced film for such twilight pictures, he increased their blueness to convey the mood of a tropical evening.

The hotel's exterior profile was long, low and regular, and this presented a compositional problem. By choosing a parasol as a foreground frame for the view at bottom right, Bryant overcame three difficulties: he added the necessary foreground interest, instantly identified the hotel, and created shade for himself and his equipment while composing the picture.

A lounge offers comfort in elegant surroundings. By choosing his viewpoint carefully, the photographer limited the amount of contrast in the scene: only in the brightly sunlit exterior beyond the window at the right side of the picture is the detail bleached out entirely.

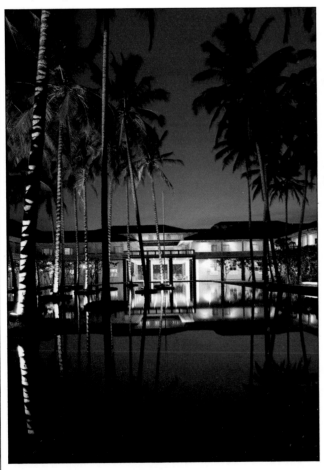

The main courtyard of the hotel glows with lights, reflected in a pool under the deep-blue sky. The lights under the trees prevented their trunks from recording as silhouettes, while the reflection of the lefthand treetrunk added strong foreground interest.

The hotel exterior sits between sand and sky. To enliven the foreground, Bryant wanted to include some fishermen who were walking on the beach, but they moved on before he could compose the picture, so he had a parasol brought out from the hotel terrace instead.

Volcanoes

Active volcanoes are among the most terrifying of all natural phenomena, and to photograph them at close quarters demands courage. Among the few photographers who have specialized in this intimidating subject are the Paris-based volcanologists, Maurice and Katia Krafft.

In a camera viewfinder, even molten lava or violent eruptions can sometimes seem distant and innocuous, especially through a wide-angle lens. The Kraffts always guard against this dangerous illusion and make every effort to protect themselves. Under extreme conditions, they wear special clothing: a helmet when the air is full of falling rocks and ashes, a gas mask in noxious fumes, and sometimes even a heat-proof suit, as shown in the picture opposite.

Cameras and lenses may come under a multiple attack from heat, corrosive vapors, dust and flying particles. The Kraffts keep all equipment stowed in a nylon case until needed, but still take along at least two extra camera bodies as insurance against damage or mechanical failure. UV filters permanently in place over all lenses protect optical surfaces; any dust or volcanic matter that hits the filters is removed with a soft brush, not with a lens cloth or tissue, which might grind particles into the glass.

Dark volcanic soil often poses an exposure problem, especially under a bright sunny sky, when the contrast is high. Usually, the Kraffts limit the sky area to a minimum or take pictures in the early morning or at dusk. When gases or vapors diffuse the light, following a meter reading may lead to a washed-out image, so it is best to underexpose by one or two stops. However, when photographing hot lava, the Kraffts generally bracket *above* the meter-judged exposure to ensure good detail in the dark areas. They take some of their most effective lava pictures at night, using long exposures. Fast-moving lava may record as a solid light trail, but ample detail shows when the flow rate is just a few yards per hour, as in the picture opposite, below.

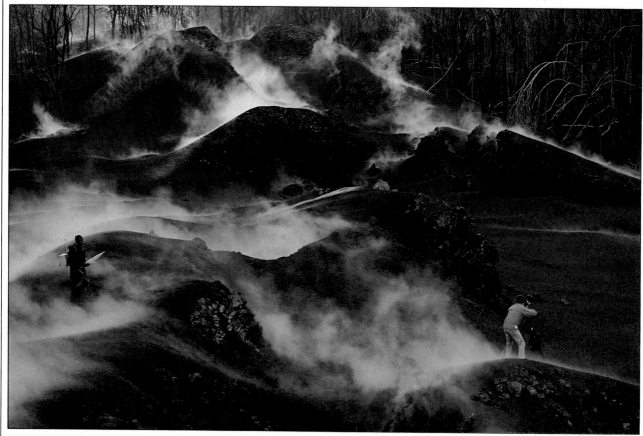

A photographer (at right) *uses a tripod-mounted camera to record the aftermath of an eruption in Zaire in 1981. Because the mounds of ashes were still warm, he kept all equipment well off the ground, as did Maurice Krafft, who took the picture from a higher slope.*

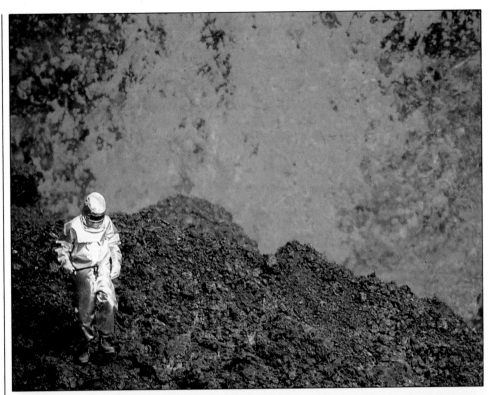

Near a volcano's heart on the island of Réunion in the Indian Ocean, Maurice Krafft wears a fireproof suit of asbestos lined with highly polished aluminum to withstand heat radiated from turbulent lava at 2,200°F (1,200°C). Normal heavy-duty climbing boots ensure that his feet are sensitive to extremely hot ground, which may indicate the presence of an underground lava flow beneath a treacherously fragile crust.

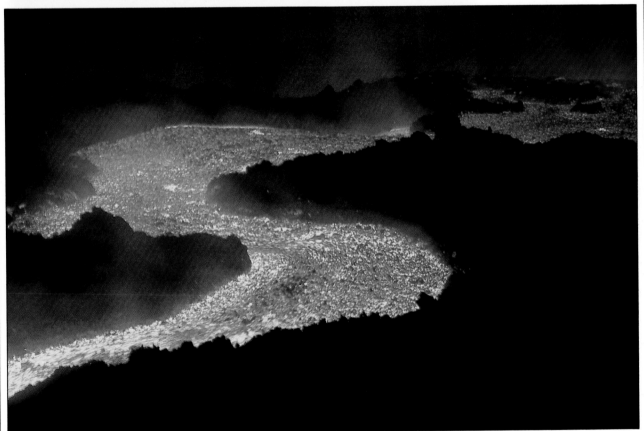

A red-hot river of lava snakes down the slopes of Mount Etna in Sicily. The photographer set the aperture at its maximum and left the shutter open for two minutes. The long exposure gave an attractive color cast to the night sky.

Jets in flight

In the late 1970s, English photographer Richard Cooke acquired a reputation for his pictures of airplanes in flight, taken from the cockpits of other planes. However, he soon came to feel that he could inject more drama into his air-to-air photography if he mounted his camera on the outside of a plane and operated it by remote control. Because his main interest was in photographing jets at high speed, there were a number of obstacles to this approach.

Air moves over the fuselage of a jet at speeds above 700 miles per hour, so one difficulty was to keep the camera securely in place on the underside of the plane. To overcome this problem, an aerodynamic housing was specially designed for him by an aerospace engineer. But on an early test flight at a high altitude and at temperatures below −58°F (−50°C), the icy wind entered the minute gaps between the lens and camera body, found its way between the shutter leaves and froze the film. The answer to this unforeseen problem, however, did not require high technology – just a strip of adhesive tape around the lens mount.

For photographs like the ones shown here, close cooperation with the pilots of both planes is vital, as is faith in their flying skills. In each case, Cooke used a wide-angle lens to dramatize the perspective. To ensure that the subjects were sufficiently dominant within the frame, the distance between the planes had to be as little as 10 feet at the moment of picture-taking.

Background plays an important part in both images. After spotting a background that would work well, Cooke asked the pilots to repeat the run, communicating to them by radio. Composing the picture without a viewfinder called for acute timing. For such views, Cooke uses a motordrive in its single-shot mode; in the continuous mode, the vital moment can occur between frames.

Wispy clouds and a rippled sea form the background to a view of a Tornado F2 in flight. A 20mm lens exaggerated the size of the nose cone in relation to the rest of the plane.

Its missiles blazing, a Harrier speeds above mud flats patterned with rivulets (right). Because this view was unrepeatable, timing was critical. The extreme danger demanded expert piloting.

Glossary

Autowinder
A battery-operated device that attaches to a camera and advances film one frame at a time. Although some autowinders can advance film at up to two frames per second, they do not have a continuous-fire facility. See also MOTORDRIVE

Available light
A general term used to describe existing light, without the introduction of any supplementary light by the photographer. Usually it refers to low illumination levels, e.g. indoors or at night.

Bracketing
A way to ensure accurate exposure by taking several pictures of the same subject at slightly different settings above and below (that is, bracketing) the presumed correct setting.

Cable release
A thin cable encased in a flexible plastic or metal tube, used to release the shutter when the camera is not being handheld. Use of the cable release helps to avoid vibration when the camera is mounted on a tripod or set on a steadying surface for a long exposure. One end of the cable screws into a socket in the shutter-release button of the camera; the other end has a plunger that, when depressed, fires the shutter. Some cable releases have locking collars that hold the shutter open for long exposures. There is also a pneumatic type of release operated by an air bulb and fitted with a long tube for remote-control photography.

Dedicated flash
A flash unit, made for a specific make of camera or range of makes, that uses the camera's TTL metering system to control light output automatically.

Depth of field
The zone of acceptable sharp focus in a picture, extending in front of and behind the plane of the subject that is most precisely focused by the lens.

Extension attachment
A camera accessory used in close-up photography to increase the distance between the lens and the film, thus allowing you to focus on very near objects. Extension tubes are metal tubes that can be added in different combinations between the lens and the camera to give various increases in lens-to-film distance. Extension bellows are continuously variable between the longest and shortest extensions. Bellows are more cumbersome than tubes and must be used with a tripod.

Field frame
A rectangular wire frame attached to the front of an underwater camera, used as a focusing aid for close-up photography.

Guide number (flash factor)
A number used to refer to the power of a specific flash unit. Dividing the guide number by the flash-to-subject distance yields the correct aperture to set at a given film speed.

Incident light
The amount of light that falls on a subject as opposed to the light emitted or reflected by the subject.

Macro lens
Strictly defined, a lens capable of giving a 1:1 magnification ratio (a life-sized image), but generally a term applied to any lens specifically designed to focus on subjects very near to the camera. Macro lenses are also used for normal photography at ordinary subject distances.

Monopod
A one-legged camera support that is usually collapsible. Although less stable than a tripod, a monopod is useful in cramped conditions, such as among crowds, or when you want to keep weight and equipment to a minimum.

Motordrive
A battery-operated device that attaches to a camera and automatically advances the film and retensions the shutter after an exposure has been made. Some motordrives can advance film at speeds of up to five frames a second.

Panning
The technique of swinging the camera to follow the direction and motion of a moving subject. Often a slow shutter speed is set so that the subject is recorded sharp against a blurred background.

Polarizing filter
A filter that changes the vibration pattern of the light passing through it, used chiefly to remove unwanted reflections in an image or to darken the sky. Rotating the filter will vary the strength of the effect.

Reciprocity failure
The occurrence of an unwanted color cast in a slide, due to an extremely long or (less often) extremely short exposure.

Reflector
Any surface capable of reflecting light, but in photography generally understood to mean sheets of white, gray or silvered cardboard employed to reflect light into shadow areas. Lamp reflectors are gener-ally dish-shaped mirrors with the bulb positioned in the center of the bowl. In studio photography, silvered umbrella reflectors are commonly used.

Ring flash
A circular flash unit fitted around the lens to produce even, shadowless lighting in close-up photography and sometimes in portraiture.

Skylight filter
A filter, usually pale pink, used to eliminate a blue color cast caused by haze. As a skylight filter does not affect exposure, it may be kept in place permanently to protect the lens from dust and scratching.

Slave unit
A photoelectric device used in studio photography to fire supplementary flash units simultaneously with the main flash.

Spot meter
An exposure meter with a $1°$ angle of coverage, used to take readings of small areas within the subject.

Teleconverter
A device that fits between a lens and camera body to increase (usually to double or treble) the effective focal length of a lens and produce a magnified image.

Telephoto lens
A long-focus lens of comparatively compact construction, which results in its being physically shorter than its focal length. Now used as a general term to describe any long-focus lens.

TTL (through-the-lens) meter
An SLR camera's built-in exposure metering system that reads the intensity of light passing through the lens.

UV filter
Lens filter used to absorb ultraviolet radiation, which is prevalent on hazy days. Like skylight filters, UV filters have no effect on the exposure.

Zoom lens
A lens of variable focal length. For example, with an 80-200mm zoom lens, the focal length can be changed anywhere between the lower limit of 80mm and the upper limit of 200mm.

Index

Page numbers in *italic* refer to the illustrations and their captions

Aerial photography, 40–2; *40–3*
 and sailing, 52–3
Airplanes, 100; *100*
Amphibious cameras, 32, 50; *10, 15, 32–3, 50*
Architectural photography, 96–7; *96–7*
Autowinder, 44
 see motordrives

Batteries, in cold conditions, 22
Bellows, 61; *61*
Black, Alastair, 50; *50–1*
Bryant, Richard, 96–7; *96–7*

Cameras, in cold conditions, 17, 22–3
 in desert conditions, 18–21; *18, 19*
 in humid conditions, 28
 large-format, 76, 96
 mountain photography, 44; *44*
 remote-control, 82–5; *82–5*
 supports, *73*
 underground photography, 46
 underwater, 32; *10, 15, 32–3*
 view, 86
 in volcanic conditions, 98
 watertight housings, 32; *32*
 in wet conditions, 26, 50; *28*
Caving, photography, 46–8; *46–9*
Close-up photography, 55, 60–4; *55, 60–5*
 underwater, 38, *38*
Clothing, for cold conditions, 22
 for hot conditions, *18*
Clouds, *26–7*
Cold conditions, 22–4; *23, 31*
Color casts, close-up photography, 62
 snow scenes, 24; *25*
 underwater, 32; *32*
Cooke, Richard, 100; *100*

Dalton, Stephen, 94; *94–5*
Dance, 72; *72*
Desert photography, 18–21; *18–21*
Double exposure, 80; *81*
Dusty conditions, 18–19; *19*

Eclipses, 69
Equipment, close-up photography, 60–1; *60–1*
 in cold conditions, 22–24; *22, 23, 25*
 in dusty conditions, 18–19; *19*
 in hot conditions, 18–21; *18*
 in humid conditions, 28
 for mountain photography, 44; *44*
 problem solving, *56, 57*
 underground photography, 46; *46*
 underwater photography, 32; *32–3*
 in wet conditions, 26
Exposure, for flash and close-ups, 64; *64*
 ice scenes, 24; *11*
 snow scenes, 24; *25, 45*
 spot meters, *9*
 underwater, 34, 36
Extension tubes, 61; *60*
Eye caps, *23*

Field frames, underwater photography, 38; *38*
Fill-in flash, 21
Film, in cold conditions, 22, 23; *17*
 in desert conditions, *18–19*
 in humid conditions, 28

pushing, 71, 90; *70, 71*
Filters, for haze, 20, 42, 44
 for lens protection, 26; *19*
 polarizing, 20; *19, 44*
 starburst, 75; *75*
Flash, in close-up photography, 64; *64–5*
 diffused, 78; *79*
 fill-in, 21
 in museums, 86
 remote-controlled, 84–5
 in tropical forests, 31; *30, 31*
 underground, 48
 underwater, 34, 36, 38; *15, 36–7*
Focusing, telephoto lens, 58
Food photography, 78; *78–9*
 on location, 90; *90–1*
Forests, 28, 31–2; *28–31*
Freezing movement, 72, 84

Haze, 20; *20*
 aerial photography, 42
 mountain photography, 44
Hot-air balloons, *13, 83*
Hot conditions, 18–20; *18*
Humidity, 28

Ice, 22–4; *22–5, 43*
Illusions, 76–80; *76–81*
Improvisation, 56–7; *56–7*
Infrared triggers, 82
Insects, *14*
 in flight, 94; *94–5*

Krafft, Maurice and Katia, 98; *98–9*

Lens hood 26, 62; *26*
Lens supports, *59*
Light, aerial photography, 42
 close-up photography, 62, 64; *62, 64*
 during rainstorms, 26
 food photography, 78; *79*
 moonlight, 66–7; *11*
 museums, 86
 painting with, 46, 48
 problem solving, 57; *57*
 reflectors, 62; *62*
 stage productions, 74–5; *74—5*
 tropical forests, 30–1
 underground photography, 48
 underwater, 32, 34; *32, 33*
 see also flash
Light aircraft, photography from, 40; *40, 41*
Light meters, stage production, 74
 underwater, 32
Lightning, 26; *27*
Lubricants, camera, 22

Macro lenses, 61; *61*
Mason, Leo, 92; *93*
Moon, 66
Moonlight, 66–7; *11*
Motordrives, aerial photography, *40*
 cold conditions, 23
 hot conditions, 18–19
 remote control, 82
Mountain photography, 44; *17, 25, 44–5*
Movement, freezing, 72, 84
Museums, 86; *86–7*

Night photography, *6, 11*
 skies, 66–9; *66–9*

Painting with light, 44, 46
Phillips, Roger, 90; *90–1*
Polarizing filters, 20; *19, 44*

Rain forests, 28, 31–2; *28–31*
Rainy conditions, 26; *12, 26–7*
Rangefinders, underwater, *15*
Reflections, glass tanks, *14*
 in rainy conditions, *12*
 snow scenes, 24
Reflectors, 21
 close-up photography, 62; *62*
Remote control, 82–5; *82–5*
Ring flash, 64

Sailing photography, 50–3; *50–3*
Sandy conditions, 18–21
Seas, 26, 50–3; *50–3*
Self-triggering systems, 84–5
Shadows, aerial photography, 42
 fill-in flash, 21
Silhouettes, 34; *9, 17, 25, 44*
Skies, night, 66–9; *66–9*
Skiing, 92; *92–3*
Snow, 22–4, 92; *22–5, 93*
Special conditions, 17–53
 desert photography, 18–21; *18–21*
 ice, 22–4; *22–5*
 rain and storms, 26; *26–7*
 snow, 22–4; *22–5*
 tropical rain forests, 28, 30–1; *28*
 underwater photography, 32–8; *32–9*
Stage productions, 70–5; *9, 70–5*
Stars, 66–9; *66–9*
Still-life photography, 76; *76–7*
Storms, 26; *26–7*

Telephoto lens, using, 51, 58, 66, 86; *52, 58–9, 67*
Telescope, photography with, 68–9; *68–9*
Through the lens metering, snow scenes, 24
Tools, emergency, 56–7; *56*
Tripods, 26, 31, 46, 56, 62, 86, 92; *59, 73*
Tropical rain forests, 28, 31; *28, 30–1*

Underground photography, 46–8; *46–9*
Underwater photography, 32–8; *10, 15, 32–9*
 close-ups, 38; *38*
 equipment, 32; *32–3*
 exposure, 34, 36
 flash, 34, 36, 38; *36–7*
 light, 32, 34; *32*
UV filters, 20, 26, 42

Viewpoint, aerial photography, 42
 in haze, 20
Volcanoes, 98; *6, 45, 98–9*

Watertight housings, 32; *32*
Wide-angle lens, desert photography, 21
 mountain photography, 44
 stage productions, 71
 underground, 46
 underwater, 32
Wildlife photography, 84–5; *84–5*

Young, Jerry, *13*

Zoom lens, in cold conditions, *23*
 for mountain photography, 44
 for sailing photography, 50 53

Acknowledgments

Picture Credits

Abbreviations used are: t top; c center; b bottom; l left; r right.
Other abbreviations: P.E.P: Planet Earth Pictures
R.H.P.L: The Robert Harding Picture Library Ltd.

Cover Y. Arthus-Betrand/Ardea

Title John de Visser. **7** Maurice & Katia Krafft/Explorer. **8** Leo Mason. **9** t Richard Haughton, b Ernst Haas/Magnum for The John Hillelson Agency. **10** Carl Roessler/Click/Chicago. **11** Bryan & Cherry Alexander/Time-Life Books. **12** Tim Eagan/Susan Griggs Agency. **13** Jerry Young. **14** Dwight R. Kuhn. **15** F. Andrade Anna/The John Hillelson Agency. **16-17** John Cleare/Mountain Camera. **18-19** Patrick Weisbecker/Explorer. **19** t Vautier-de Nanxe. **20** David Simpson/Camerapix Hutchison. **21** l Bryan & Cherry Alexander, r Michael Freeman. **23** Graham Land/Antarctica/John Noble-Mountain Camera. **23** t Bryan and Cherry Alexander/Time-Life Books. **24-25** John Cleare/Mountain Camera. **25** t Stephen J. Krasemann/Bruce Coleman, b John Cleare/Mountain Camera. **26** t George Carde/Explorer, b Brian Brake/The John Hillelson Agency. **26-27** Edouard Bernager/Explorer. **27** t Hans Wendler/Image Bank. **28** l Michael Freeman/Bruce Coleman. **28-29** Brinsley Burridge/R.H.P.L. **30** l Brian J. Coates/Bruce Coleman. **30-31** Frithfoto/Bruce Coleman. **31** r Brian Rogers/Biofotos. **32** t, c, b all Flip Schulke/P.E.P. **32-33** Warren Williams/P.E.P. **33** t, b Flip Schulke/P.E.P. **34-35** Warren Williams/P.E.P. **35** t Flip Schulke/P.E.P., r Kurt Amsler/P.E.P. **36** t, c Peter Scoones/P.E.P. **36-37** Herwarth Voigtmann/P.E.P. **37** Laurence Gould/P.E.P. **38** Soames Summerhays/Biofotos. **39** t Carl Roessler/P.E.P., b Carl Roessler/Click/Chicago. **40-41** Martin Rogers/Susan Griggs Agency. **41** t Jerry Young, r Sergio Dorantes. **42** t Heather Angel/Biofotos, b George Hall/Susan Griggs Agency. **43** t Don Landwehrle/Image Bank, b Ian McMorrin/Mountain Camera. **44** t David Higgs, b John Cleare/Mountain Camera. **45** John Cleare/Mountain Camera. **46** l Chris Howes. **46-47** Anthony C. Waltham/R.H.P.L. **47** t Michael Nichols/Susan Griggs Agency, b Anthony C. Waltham/R.H.P.L. **48** t Michael Nichols/Susan Griggs Agency, l Anthony C. Waltham/R.H.P.L., br Michael Nichols/Susan Griggs Agency. **49** Michael Nichols/Susan Griggs Agency. **50-53** all Alastair Black. **56-57** Ernst Haas/Magnum for The John Hillelson Agency. **58** t Paul Keel, b Michael Freeman. **59** Michael Freeman. **60-61** all Heather Angel/Biofotos. **63** t Dwight R. Kuhn, b Vaughan Fleming/Science Photo Library. **65** Anthony Healy/Bruce Coleman. **66** Dr. F. Espenak/Science Photo Library. **67** l David Higgs, r Martin Dohrn/Science Photo Library. **68** Ronald Royer/Science Photo Library. **69** tl Ian Robson/Science Photo Library, b Royal Astronomical Society. **70** l Richard Haughton. **70-71** Laurie Lewis. **71** r Laurie Lewis. **72** t Darryl Williams/The Dance Library, b John Starr. **73** Richard Haughton. **74** t, b Richard Haughton. **75** l Darryl Williams/The Dance Library, r Robin Laurance. **76** Tony Skinner. **77** t Nels, b Tony Skinner. **78** Tom Petroff/Click/Chicago. **79** t, b Anthony Blake. **80-81** all Nels. **82** Leo Mason. **83** l, r Jerry Young. **84** all Stephen Dalton/N.H.P.A. **86** tl, bl Sergio Dorantes, r Brian Brake/The John Hillelson Agency. **87** Robin Laurance. **88-89** Leo Mason. **90-91** all Roger Phillips. **92-93** all Leo Mason. **94-95** all Stephen Dalton/N.H.P.A. **96-97** all Richard Bryant. **98-99** all Maurice & Katia Krafft/Explorer. **100-101** all Richard Cooke.

Additional commissioned photography by John Miller, Mike Newton, George Taylor.

Acknowledgments Greenaway Marine Ltd, Wallace Heaton, Keith Johnson Photographic, Nikon UK, Ocean Optics Ltd, Pelling & Cross, Pentax U.K.

Artists David Ashby, Gordon Cramp, Tony Graham, David Mallott, Coral Mula

Kodak, Ektachrome, Kodachrome and Kodacolor are trademarks